IMAGES
of America

BRIDGES OF THE OREGON COAST

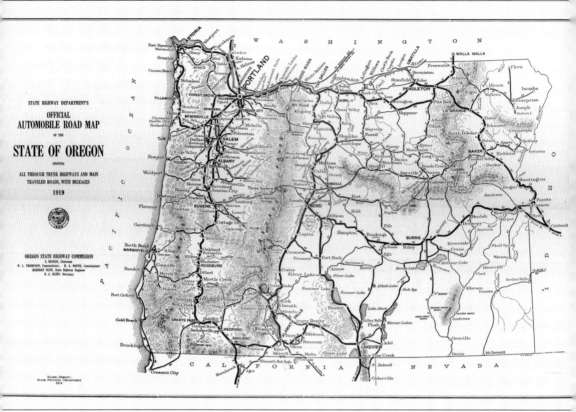

STATE HIGHWAY DEPARTMENT'S

OFFICIAL
AUTOMOBILE ROAD MAP
OF THE

STATE OF OREGON
SHOWING

ALL THROUGH TRUNK HIGHWAYS AND MAIN
TRAVELED ROADS, WITH MILEAGES

1919

OREGON STATE HIGHWAY COMMISSION
S. BENSON, Chairman
W. L. THOMPSON, Commissioner, R. A. BOOTH, Commissioner
HERBERT NUNN, State Highway Engineer
R. A. KLEIN, Secretary

SALEM, OREGON:
State Printing Department
1919

This early Oregon State Highway Department map, showing the Oregon Coast Highway in its infancy c. 1919, illustrates the relative isolation of the coast compared to other more populated regions. There was no Oregon Coast Highway between Neskowin and North Bend, a distance of approximately 136 miles. A trip from Florence to nearby Gardiner/Reedsport, which today would be 21 miles, would have taken 150 miles on the state highway system of 1919. As the Oregon Coast Highway was developed, the ferries that crossed Yaquina Bay, Alsea Bay, the Siuslaw River, the Umpqua River, Coos Bay, and the Rogue River became unable to keep up with the traffic. Completion of the bridges featured in this book eliminated the ferries, which were the last obstacles, and made the Oregon Coast Highway continuous between the Columbia River and the California border. (Courtesy Oregon Department of Transportation [ODOT].)

ON THE COVER: This volume chronicles the construction of six major bridges on the Oregon Coast Highway during the depths of the Great Depression. Pictured on the cover is the largest of these, the 5,305-foot-long Coos Bay (Conde Balcom McCullough Memorial) Bridge, in a photograph taken on November 25, 1935. The bridge is partially completed with the two ends of the steel cantilever truss reaching toward each other, portions of the steel cantilever truss painted and other portions unpainted, the roadway deck in place on some of the concrete arch spans but not others, and some of the handrail installed. The curved upper and lower surfaces of the cantilever truss and the concrete arch approaches produce an uncommonly graceful cantilever bridge. This bridge was dedicated posthumously in 1947 to its designer, Conde Balcom McCullough, the mastermind behind the Oregon Coast Highway's excellent collection of aesthetic bridges. (Courtesy ODOT.)

IMAGES
of America

BRIDGES OF THE OREGON COAST

Ray Bottenberg

ARCADIA
PUBLISHING

Published by Arcadia Publishing
Charleston, South Carolina

Printed in the United States of America

Library of Congress Catalog Card Number: 2006927533

For all general information contact Arcadia Publishing at:
Telephone 843-853-2070
Fax 843-853-0044
E-mail sales@arcadiapublishing.com
For customer service and orders:
Toll-Free 1-888-313-2665

Visit us on the Internet at www.arcadiapublishing.com

For my wife, Jeanna, and our son Ian, you are cherished blessings.

This photograph from a concrete pour on the Umpqua River Bridge at Reedsport on October 22, 1934, shows Dexter Smith, one of the designers of the Coos Bay Bridge, at center. The man at left may be Conde B. McCullough, Oregon state bridge engineer. McCullough was ultimately responsible for the design of the Oregon coast bridges, but he relied on his staff engineers, many of whom were brilliant in their own right, to produce design calculations and plans for each bridge. One engineer, Ivan Merchant, recalled in later years that "Mac would lay out the overall job. He would pick up a piece of paper and a pencil and say 'Now . . . this is about what you are going to do.' And he drew this spandrel arch in there and the roadway . . . and there it is. 'Go ahead.' [he said] . . . And about every two or three weeks, he'd come back to see how you were getting along." (Courtesy ODOT.)

CONTENTS

ACKNOWLEDGMENTS

I wish to thank Robert W. Hadlow, Ph.D., of the Oregon Department of Transportation for offering many helpful suggestions and for reviewing the completed book; the Oregon Department of Transportation and the Oregon State Archives for providing the bulk of the images used in this book; and Kenneth Archibald, son of engineer Raymond Archibald, and Carol Thilenius, daughter of photographer Cecil Ager, for granting permission to use selected photographs.

I also wish to recognize the following individuals for the guidance and assistance they have provided that helped make this book possible: Tom Ohren, Chris Leedham, Greg Westergaard, Lloyd Bledsoe, Pat Solomon, and Frank Nelson of the Oregon Department of Transportation; Layne Sawyer and Gary Halverson of the Oregon State Archives; and fellow bridge enthusiast Robert Cortright.

INTRODUCTION

Before 1900, the Oregon coast was relatively isolated, and travel was difficult. The easiest way to get to the coast was by railroad, but railroads served only a few communities, and the easiest way to travel along the coast often required an ocean-going vessel. Automobile travel was so difficult that the first automobile trip from Newport to Siletz Bay, a journey of 47 miles, took 22 hours and 40 minutes in 1912.

During the first three decades of the 20th century, automobiles became commonplace and clogged the ferries crossing the coast's larger bays and rivers. In 1913, the Oregon State Highway Commission (OSHC) and the Oregon State Highway Department (OSHD) were created by act of the Legislative Assembly, and in 1917, the Legislative Assembly authorized a $6 million highway construction bond issue for the purpose of "getting Oregon out of the mud." In 1919, the Legislative Assembly increased the highway construction bond issue by $10 million, submitted legislator Ben Jones's referendum for a defense route along the coast known as the Roosevelt Military Highway, and enacted the nation's first gasoline tax, 1¢ per gallon of vehicle fuel to be used exclusively for highway improvement. Voters approved the $2.5 million bond obligation for the Roosevelt Military Highway but federal matching funds were lost, and the state's authority to sell the bonds lapsed. By the late 1920s, the OSHC recognized the ferries as an impediment to development of the coast. Beginning in 1927, the state took over operation of private ferries at Gold Beach, Coos Bay, Reedsport, Florence, Waldport, and Newport. The ferries operated 16 hours per day when they were not closed due to low or high water.

On April 9, 1919, the McCullough era began when Conde B. (C. B.) McCullough, head of the civil engineering program at Oregon Agricultural College, joined the OSHD as the second Oregon state bridge engineer. With approval of the College Board of Regents, he "liberated" four of his five graduating structural engineers to begin work in the OSHD's Bridge Section. These four engineers were field engineers Ellsworth "Rick" Ricketts, A. G. "Al" Skelton, and P. M. "Steve" Stephenson, and staff engineer Raymond "Peany" Archibald. McCullough also brought former classmates from Iowa State College to work in Bridge Section, including chief design engineer Owen A. Chase, office engineer William Reeves, and assistant bridge engineer Merle Rosecrans.

McCullough guided the Bridge Section through the design of six major bay and river crossings that connected the Oregon Coast Highway and replaced the clogged ferries. The first of these bridges was the Rogue River Bridge at Gold Beach. Following its completion, the state planned to build one major coastal bridge each year. In June 1932, the Oregon Coast Highway Association met in Waldport to press for construction of more bridges and to seek funding from Herbert Hoover's Reconstruction Finance Corporation. When Hoover lost the election to Franklin D. Roosevelt, the program was cancelled and Oregon's Republican senator Charles McNary lobbied for Roosevelt's National Industrial Recovery Act/Public Works Administration (PWA) and then pushed the OSHC to apply to the PWA for funding of five major coastal bridges. The combined projects were expected to employ 750 workers for up to two years and an additional 375 workers supplying materials for construction.

During a six-month period, McCullough and Bridge Section worked day and night shifts to complete drawings for bridges at Yaquina Bay, Alsea Bay, Siuslaw River, Umpqua River, and Coos Bay. McCullough brought some of his field engineers into Salem and added new engineers, including Ivan Merchant and A. E. Johnson.

The Navigation Act of 1906 required congressional approval for bridges spanning any shipping channels subject to War Department authority. On May 11, 1933, Sen. Charles McNary introduced

five bills authorizing the state to "construct, maintain, and operate" the proposed bridges. Pres. Franklin D. Roosevelt signed the bills into law June 12, 1933.

Coastal residents and the National Lumber Manufacturer's Association initially felt that the bridges should be constructed of wood to help the local lumber industry. McCullough was against this since steel and reinforced concrete bridges would last much longer with less maintenance, and the War Department would not approve wooden bridges for these sites. State officials also pointed out that the falsework, the structure to support forms for reinforced concrete, would require nearly as much lumber as bridges built directly from wood. McCullough feared that the controversy would delay and jeopardize approval of the PWA funding. Eventually the coastal communities supported the steel and reinforced concrete bridges, anxious to avoid losing the federal money and the jobs and business revenue it would bring.

With the plans completed, on January 6, 1934, the PWA agreed to grant the state $1,402,000 and loan the state $4.2 million to be repaid through the sale of bonds. The state opted, with federal approval, to sell the bonds on the open market for a more advantageous interest rate. In 1934, contracts were awarded for construction of the five bridges.

In December 1935, McCullough and Raymond Archibald left to work on bridge designs for the Inter-American Highway in San Jose, Costa Rica. Glenn Paxson became the Oregon state bridge engineer and oversaw the completion of the five bridges.

The five bridges were completed in 1936, eliminating the ferries and making the Oregon Coast Highway continuous for the length of the state. The project also fulfilled a PWA goal of providing jobs for workers unemployed by the Great Depression. Construction of the five bridges required over 2.1 million man-hours of labor directly on the bridges and consumed 54,000 cubic yards of sand, 10,000 cubic yards of gravel, and 182,000 barrels of cement. Another important benefit of the projects was a 72 percent increase in coastal tourism in one year.

The bridges capped the McCullough era, reflecting his preference for reinforced concrete arches and practical, cost-effective, and aesthetically pleasing bridges. Their architecture combines classical and Gothic-style elements with the popular art deco and Moderne influences of the late 1920s and the 1930s. Their supporting piers and bents are tiered and ornamented in the art deco style, with vertical detailing and surfaces broken by scoring strips, and the web walls between the main columns of the bents are cut away in the form of Gothic arches with sunburst rays. When the piers and bents are viewed in line, the Gothic-style arched openings are reminiscent of the roof framing of European cathedrals. The handrail panels on the Umpqua River Bridge have a unique flower-shaped pattern, and the handrail panels on the other four bridges have patterns of small, stylized Gothic-style arches similar to the openings beneath the bents, stepped back in the art deco/Moderne philosophy to create shadow lines and increase visual interest.

McCullough's views on aesthetics are suggested in a letter he wrote in 1937, "From the dawn of civilization up to the present, engineers have been busily engaged in ruining this fair earth and taking all the romance out of it. They have cluttered up God's fair landscape with hideous little buildings and ugly railroads. The highway builders have ruined all the fishing so that there is no place where one can go and get away from it all. As a last and final insult, there appears to be a movement on foot to clutter up the right of way with blazing artificial lights at night so that there will be no place on the road for the young folk to park and engage in their usual amorous avocations. Personally I am too old for this to make any difference, but, nevertheless, I deplore it." McCullough chose to describe the coastal bridges as "jewel-like clasps in perfect settings, linking units of a beautiful highway."

McCullough passed away May 6, 1946, from a massive stroke, and in 1947, the state dedicated the Coos Bay Bridge as the Conde Balcom McCullough Memorial Bridge.

GLOSSARY

BASCULE-TYPE DRAWBRIDGE—A movable bridge type having one (single leaf) or two (double leaf) spans hinged at a pier, to open upward away from the navigation channel (see Siuslaw River Bridge).

BATTER PILING—A piling driven at a slight angle, used where resistance to horizontal loading is needed.

BENT—A vertical structure supporting the spans of a bridge, typically on land.

CANTILEVER—A type of truss in which the main span is supported by two piers at each end (see Coos Bay Bridge).

CARTOUCHE—A scroll-like figure.

COFFERDAM—Temporary structure, typically made by driving sheet piling around an in-water work area such as in bridge pier construction, that is pumped out to dewater the work area.

CONSIDÈRE HINGE—A construction detail used to reduce built-in bending stresses in reinforced concrete arch ribs. The Considère Hinge, named for French engineer Armand Considère, is a temporary hinge that is reinforced and closed with a concrete pour after the dead load is applied to the arches.

CREEP—The tendency of concrete to change dimensions slightly under long-term loading.

DEAD LOAD—The self-weight of the bridge components.

DECK—The portion of the bridge structure that provides a roadway surface to carry traffic.

DECK ARCH—An arch bridge structure type with its deck supported by spandrel columns above arch ribs.

DOLPHIN—Structure independent of bridge used to protect bridge piers against errant vessels and drift.

DONKEY—A steam-powered hoisting engine, mounted on skids with a vertical boiler and equipped to haul in one or more wire ropes, commonly used in logging. Bridge contractors found donkeys useful when they improvised cranes, pile drivers, and other equipment.

FALSEWORK—Temporary structure used to support concrete forms during construction.

FENDER—Structure to protect bridge piers against errant vessels and drift.

FREYSSINET METHOD—A method of reinforced concrete arch construction in which a short section of the arch ribs is temporarily left open at the crown, then jacks are placed in the openings and the arch rib segments are jacked away from each other just enough to compensate for creep and shrinkage of the concrete, shortening due to dead loads, and stresses caused by temperature changes. After jacking, the reinforcement from each segment of arch rib is connected and the crown of the arch is closed with a final concrete pour.

HANGER—Structure member that transfers loads from the roadway deck to the arch rib in a tied arch type bridge.

HYDROSTATIC PRESSURE—Pressure caused by the weight of a fluid such as water above and around a submerged structure, acting in all directions and tending to collapse submerged structures.

LIVE LOAD—Weight of vehicles, persons, and cargoes carried by the bridge.

PALLADIAN—A Renaissance architectural style originated by Andrea Palladio.

PIER—Vertical structure supporting the spans of a bridge, typically in water.

PILE/PILING—Long, slender foundation component, typically timber, driven into the soil.

PORTAL—The entryway from open roadway into an overhead bridge structure.

PRESTRESSED CONCRETE—Concrete components strengthened by providing reinforcement that is under stress when the concrete is cast. Prestressing increases a component's load-carrying capacity and its durability.

REINFORCED CONCRETE DECK GIRDER—Bridge structure type with girders and floor beams cast integrally with the roadway deck.

RIPRAP—Large rock placed around bridge piers and other underwater structures to protect them from the scouring action of rivers and tides, which tends to undermine foundations.

SEAL—First layer of concrete poured at the bottom of piers to seal water out of the cofferdam.

SHEET PILING—Wooden planks or corrugated steel driven into soil, typically used to construct cofferdams and retaining walls.

SHORING—Temporary structure provided to prevent collapse of cofferdams or excavations during construction.

SHRINKAGE—The tendency of concrete to shrink slightly as it cures and ages.

SPAN—Distance between vertical supports.

SPANDREL COLUMN—Structure member that transfers loads from the roadway deck to the arch rib in a deck arch type bridge.

STRESS—Force per unit area carried by a structural member. Bridge designers size structural members so that the stresses due to loads the bridge must resist are less than allowable stress values for the material.

SWING-TYPE DRAWBRIDGE—Movable bridge type having one span that pivots around a central pier providing two navigation channels (see Umpqua River Bridge).

TEMPERATURE STRESSES—Stresses induced in a structure by temperature changes when portions of a structure are prevented from expanding or contracting freely.

TIED ARCH—An arch bridge structure type in which the deck resists the tendency of the arch ribs to push their piers apart. Hangers support the deck from the arch ribs.

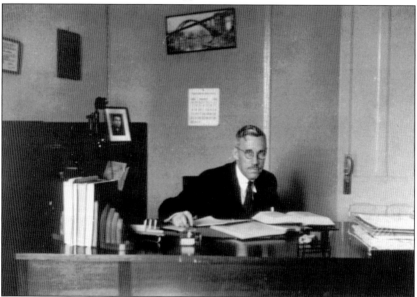

Oregon state bridge engineer Conde B. McCullough is pictured here at work. On the wall behind him is a photograph of the Willamette River Bridge built in 1923 at Oregon City, a steel arch coated with a protective layer of "gunite," a material similar to concrete. McCullough designed bridges in the Midwest for several years before coming to Oregon to head Oregon Agricultural College's civil engineering program. In 1919, he was selected to lead the Oregon State Highway Department's Bridge Section and brought four of his five graduating engineers and three of his former classmates from Iowa State College to form a bridge engineering staff. McCullough was responsible for the design of hundreds of bridges in Oregon during the period of 1919 through 1936 and became widely known as an expert in the design of reinforced concrete arch bridges and the design of bridges to be both economical and aesthetically pleasing. (Courtesy ODOT.)

One

Rogue River Bridge (Gold Beach)

Before building the Rogue River Bridge, the Oregon State Highway Department operated a ferry, *The Rogue*, that crossed the river between Gold Beach and Wedderburn. *The Rogue* was taken out of service during a high flood at 8:00 p.m. on December 24, 1931, when the new bridge was quickly opened to traffic, and the ferry was towed to Waldport to supplement Alsea Bay ferry service. The design of the Rogue River Bridge was completed by C. B. McCullough and his staff, including O. A. Chase and Claude Darby, in 1929 after the United States Army Corps of Engineers granted the state a permit to build the bridge. Field engineering staff on the project included assistant bridge engineer in charge of construction G. S. Paxson, resident engineer Marshall Dresser, assistant resident engineer Ivan Merchant, concrete technician O. R. Kennen, and test equipment installation designing engineer Edward Thayer. (Courtesy ODOT.)

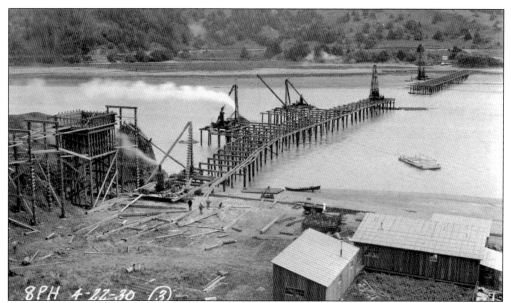

The first step in building the bridge was to construct a work bridge. Pile drivers are driving the supports for the work bridge from both sides of the river in this April 22, 1930, view. Also pictured are work platforms for excavation of several piers, the contractor's sheds, a barge, a rowboat, and the contractor's concrete plant under construction at the left. (Courtesy ODOT.)

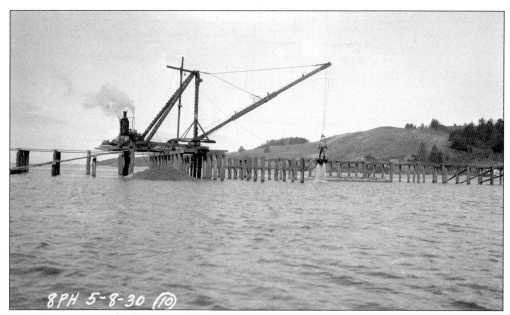

Once the contractor had access to the pier sites, the crew began excavating. This view shows the contractor's excavating rig working at a pier on May 8, 1930. A steam donkey engine powers this contractor-built shovel. The $568,181 construction contract was awarded to the Mercer-Fraser Company of Eureka, California, on January 16, 1930. (Courtesy ODOT.)

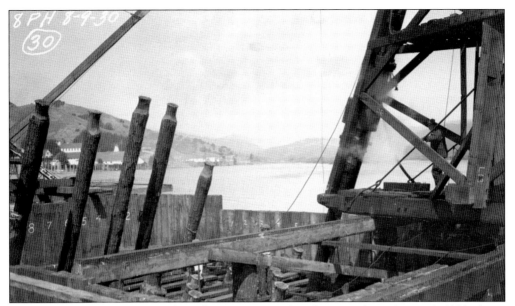

Several piers required batter piling, driven at an angle. This view from August 9, 1930, shows Mercer-Fraser's Vulcan steam hammer driving batter piling, which was designed to resist horizontal thrust forces from the deck arches. Also visible are wooden sheet piling that form the cofferdam for this pier. When the water was pumped out, the cofferdam provided access to work at the bottom of the pier. (Courtesy ODOT.)

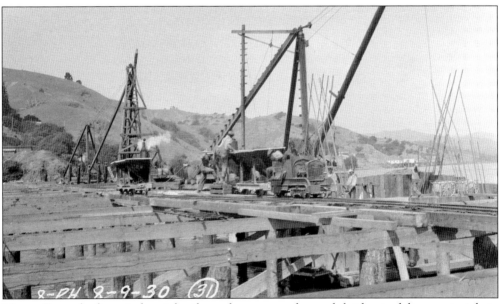

Mercer-Fraser built an industrial railway that ran on the work bridge to deliver materials to the work site. The locomotive, pictured here hauling concrete to a pier on August 9, 1930, was made from parts of a Ford Model T. Construction of the bridge consumed 15,591 cubic yards of concrete. (Courtesy ODOT.)

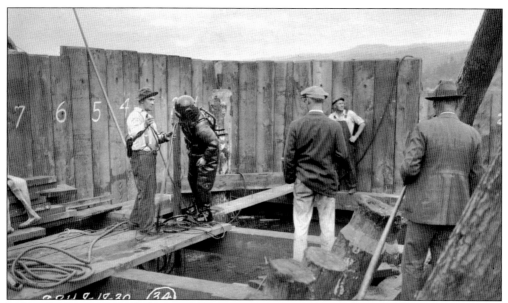

Before the water in a cofferdam could be pumped out, divers cut off the piling and a layer of seal concrete was poured at the bottom of the pier in the water. The diver in this view is preparing to cut off batter pilings on August 18, 1930. The pilings were cut off to leave a few feet protruding after the seal was poured. (Courtesy ODOT.)

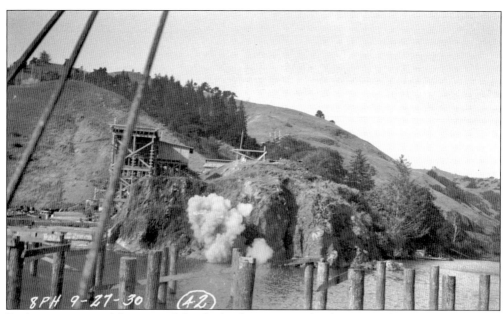

Explosives were used for some of the dry-land excavation for the pier at the north bank of the river. Pictured here on September 27, 1930, is the first blast at the beginning of excavation of this pier. Visible in the background is Mercer-Fraser's concrete plant. Excavation for the bridge removed a total of 10,174 cubic yards of earth. (Courtesy ODOT.)

14

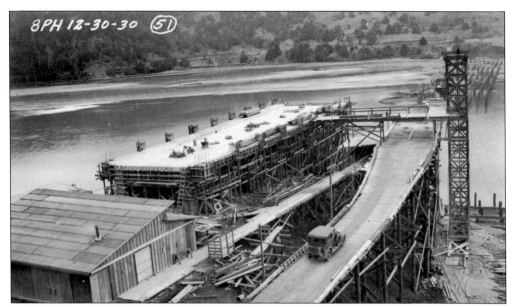

The automobile in this December 30, 1930, view is traveling the ramp to the concrete plant bunkers. Also visible is a section of approach roadway, with deck and some forms for handrail posts in place, and one of Mercer-Fraser's sheds. The approach roadway is a reinforced concrete deck girder span, a type of construction with girders and deck slab cast integrally. (Courtesy ODOT.)

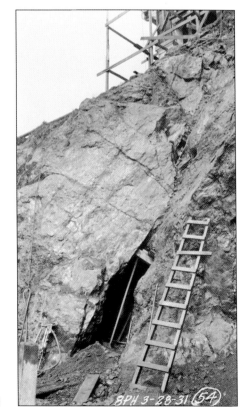

While excavating for the pier at the north bank of the river, a large fissure was found in the supporting rock. This view from March 28, 1931, shows the fissure before excavating and cleaning, which kept 46 to 61 laborers working steadily for two weeks before the rock was considered acceptable to support the pier. (Courtesy ODOT.)

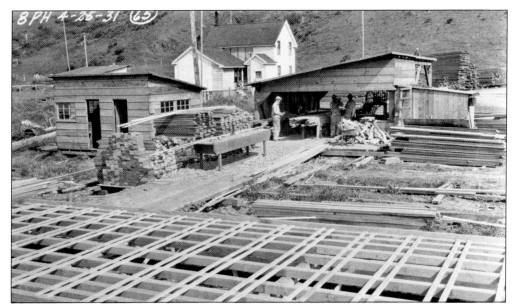

Construction of a large concrete arch bridge required a massive amount of timber to build forms and falsework, which was the temporary structure that supported the forms. Pictured in this April 25, 1931, scene is the shed and yard where Mercer-Fraser's carpenters laid out and built the forms and falsework. (Courtesy ODOT.)

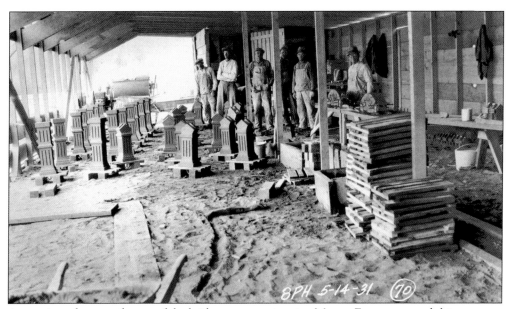

Approximately one mile east of the bridge construction site, Mercer-Fraser operated this concrete precasting yard in which their workers made concrete parts for the handrail. This photograph shows the workers on May 14, 1931, with one half-day's work. A nine-cubic-foot Blystone mixer is in the background. (Courtesy ODOT.)

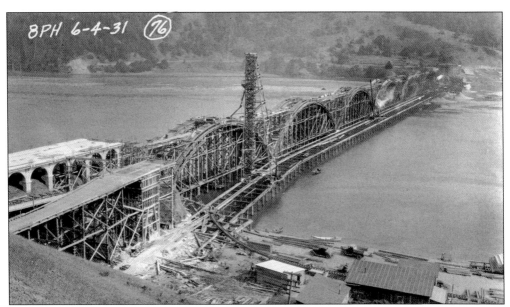

Five and a half spans of falsework were complete and three and a half spans of arch rib forms were 75 percent complete by June 4, 1931. In this view, a 104-foot-high mobile concrete-hoisting tower and Insley placing attachment is visible on the work bridge next to the first arch span. The arch spans are deck arches, which is a bridge structure type with arch ribs below the roadway deck. (Courtesy ODOT.)

The Rogue River Bridge was part of a study conducted jointly by Oregon State Highway Department and the U.S. Bureau of Public Roads. Photographed on June 19, 1931, this scale model of the arch rib forms was made to demonstrate the installation of McCollum-Peters cartridge type electric telemeters. Telemeters were early devices that could be embedded in concrete and monitored electrically to determine the stress on a structural member. (Courtesy ODOT.)

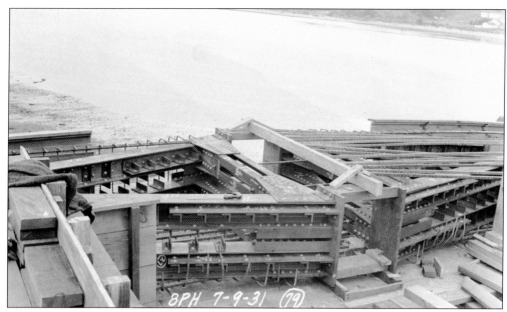

The engineers examined the Freyssinet method of concrete arch construction in which jacks were placed at the crown of the arch rib to push the arch rib segments away from each other just enough to counteract the built-in stresses in the arch rib. This view from July 9, 1931, shows the structural steel jacking brackets that were embedded at the crown of the arch ribs. (Courtesy ODOT.)

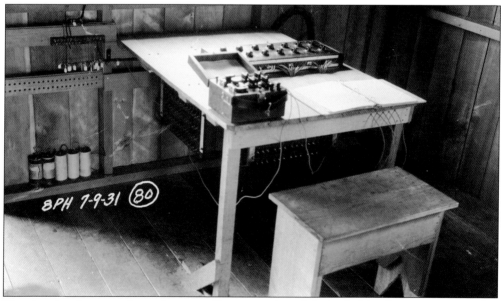

The electric telemeters pictured on page 17 were monitored during jacking by an engineer at this worktable photographed on July 9, 1931. The equipment pictured includes a switchboard and a wheatstone bridge, which is an electrical circuit for the precise measurement of resistances that improves the accuracy of structural stress measurements. (Courtesy ODOT.)

Workers are placing concrete using carts and finishing concrete in this August 28, 1931, photograph. A chute from the mobile concrete hoisting tower, pictured on page 17, feeds wet concrete into the hopper used to load the carts. The roadway deck is 27 feet wide and the overall width, including sidewalks, is 36 feet. (Courtesy ODOT.)

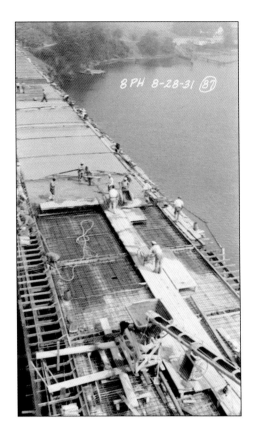

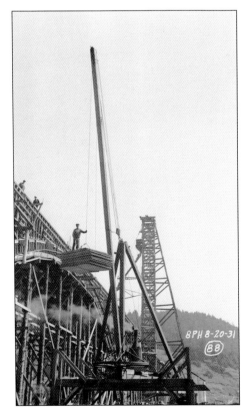

Mercer-Fraser's traveler derrick is hoisting prefabricated deck forms and one worker in this view on August 20, 1931. The curved forms for the arch rib are visible along with straight forms for the reinforced concrete deck girder roadway and the falsework supporting the arch rib. The derrick is powered by a steam donkey engine. (Courtesy ODOT.)

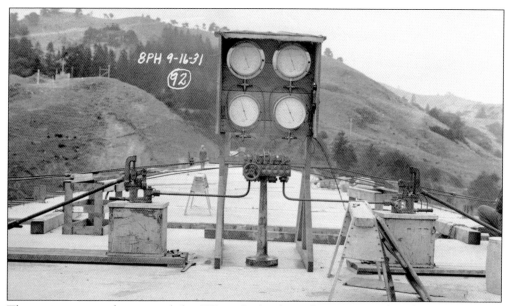

The equipment used to control the 275-ton hydraulic jacks is seen in this photograph dated September 16, 1931. The equipment includes pumps, manifold piping, and pressure gauges for the water, which was used as the working fluid. Eugène Freyssinet developed the method bearing his name in France in 1908 to help prevent cracking and sagging in relatively flat arches. (Courtesy ODOT.)

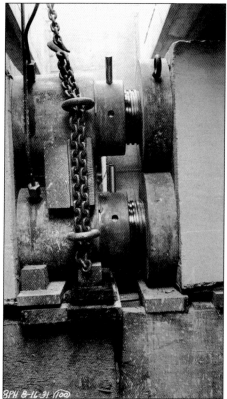

Two of the four jacks required at each arch rib for the Freyssinet method of concrete arch construction are pictured here on August 16, 1931. The force from these jacks counteracted stresses due to creep and shrinkage of concrete, shortening of concrete due to weight of the structure, and stresses caused by temperature changes. (Courtesy ODOT.)

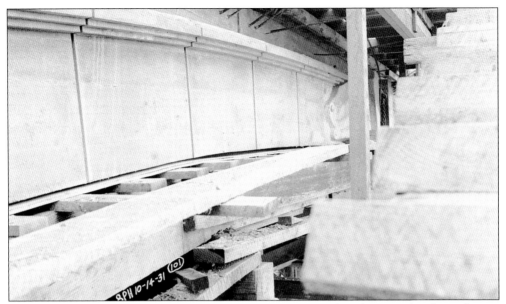

The arch rib was lifted off the forms during jacking as pictured in this view dated October 14, 1931. This was the highest point in the jacking operation. After the arch was jacked to this point, reinforcing bars were welded together and concrete was poured to make the arch ribs continuous. The jacks were then removed. The vertical scoring and stepped molding on the sides of the arch rib are decorative. (Courtesy ODOT.)

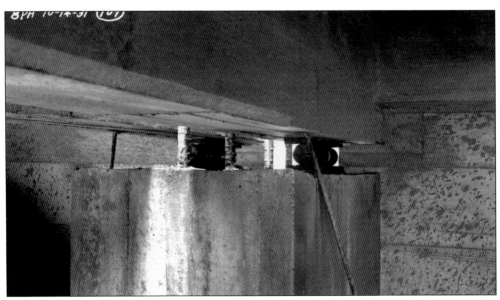

Temporary rollers were installed between the deck and spandrel columns, which support the deck atop the arch ribs, to prevent the deck and spandrel columns from restraining the arch ribs during jacking. These temporary rollers were later encased in concrete. This view showing the temporary rollers is dated October 14, 1931. (Courtesy ODOT.)

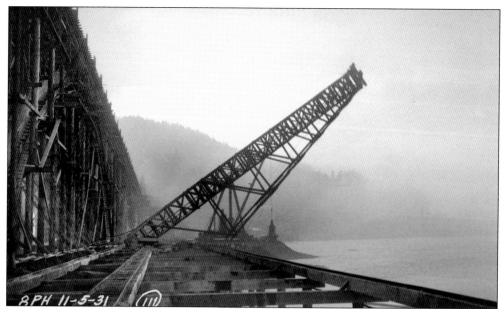

A 104-foot hoisting tower fell down while dismantling equipment on November 5, 1931. This photograph offers a good view of the work bridge and Mercer-Fraser's industrial railway. Some of the forms and falsework for the bridge are also visible. Foggy and rainy weather is typical on the Oregon coast much of the year. (Courtesy ODOT.)

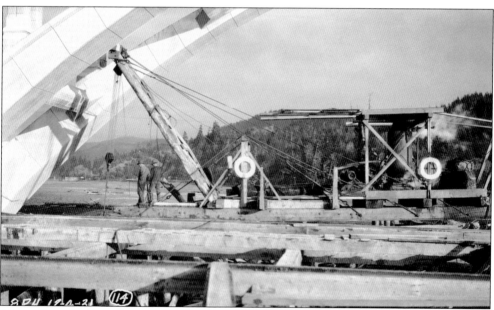

Mercer-Frazer's pile puller is pictured pulling piling that had supported falsework beneath the arch in this December 4, 1931, view. The pile puller appears to be improvised by Mercer-Fraser and powered by a steam donkey engine. December 4 was a sunny day, and the newly constructed arch ribs and columns appear very bright. (Courtesy ODOT.)

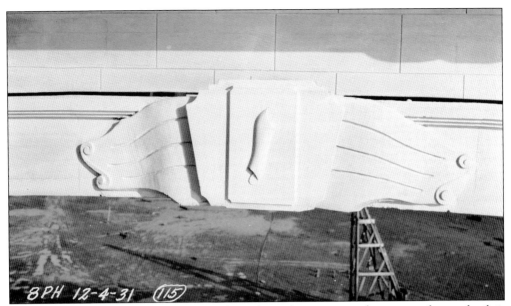

The ornamental cartouche that covers the jack emplacements at the crown of an arch rib is illustrated in this view dated December 4, 1931. The Rogue River Bridge was the first in the United States to use the Freyssinet method of concrete arch construction, considered to be the precursor to modern prestressed concrete construction, which achieves superior strength by casting the concrete with the reinforcing strands under stress. (Courtesy ODOT.)

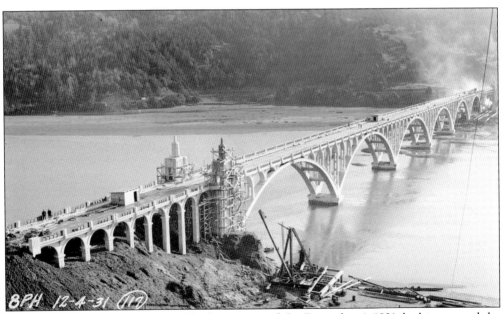

The nearly completed Rogue River Bridge is pictured On December 4, 1931, looking toward the southeast. Workers are building handrail to the left, Mercer-Fraser's shacks and materials can be seen on the bridge, and the entrance pylons are surrounded by scaffolding. The bridge was the site of a worker's wedding one night in December. (Courtesy ODOT.)

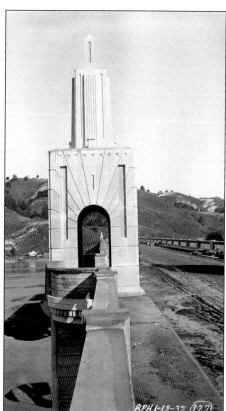

One of the entrance towers on the Gold Beach end of the bridge is pictured here on January 13, 1932. The entrance tower, decorated with a semicircular arched doorway with Egyptian sunbursts radiating from it, provides a major visual effect and a place for pedestrians to escape the weather. (Courtesy ODOT.)

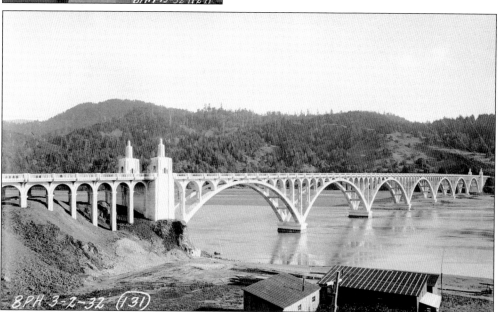

The completed Rogue River Bridge is pictured here from the northwest on March 2, 1932. The Mercer-Fraser Company presented the new bridge to the state on January 21, 1932, and the bridge was officially accepted as complete on January 27, 1932, at a final cost of $592,725.56. (Courtesy ODOT.)

In this March 4, 1932, photograph, one of the entrance towers is viewed from the opposite side of the bridge looking toward the east. Architectural treatments include two graceful reductions in the width of the tower as it reaches upward, palladian windows, and elaborate vertical and horizontal fluting, providing an interesting view and imposing appearance. The overall length of the Rogue River Bridge is 1,938 feet, and it has seven 230-foot reinforced concrete deck arches and reinforced concrete deck girder approaches. Construction of the bridge required the excavation of 10,174 cubic yards of earth and consumed 27,016 lineal feet of piling, 15,591 cubic yards of concrete, 1,764,981 pounds of reinforcing steel, and 114,109 pounds of structural steel. (Courtesy ODOT.)

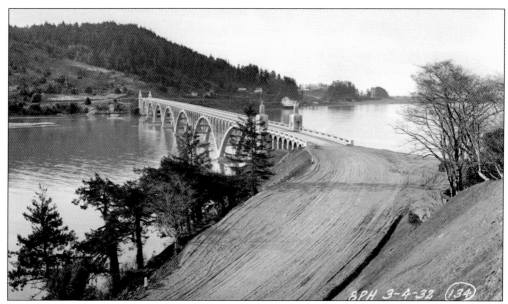

This photograph of the bridge was taken from Wedderburn on March 4, 1932. It was dedicated on May 28, 1932, as the Isaac Lee Patterson Memorial Bridge in a celebration that included an official program, a salmon luncheon, marching bands, a carnival dance, motorboat races, and a "jitney" dance. Patterson was the governor of Oregon from 1927 until 1929 when he died in an airplane crash. (Courtesy ODOT.)

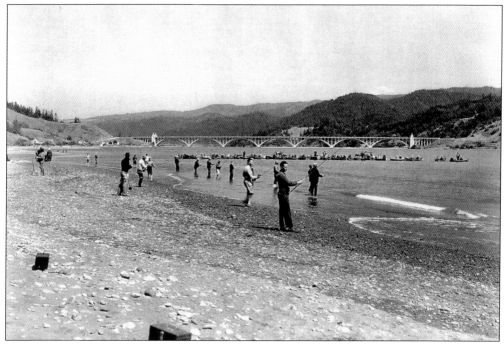

This view by photographer Cecil Ager shows a crowd of fishermen near the mouth of the Rogue River, a popular spot at the beginning of salmon season. The Oregon coast bridges helped open the coast for recreation and tourism, which are a major part of the coastal economy today. (Courtesy Carol Thilenius.)

Two

YAQUINA BAY BRIDGE (NEWPORT)

At the beginning of the project, the contractor built work bridges to provide construction access to the portions of the bridge outside of the navigation channel and a railway along the north shore to deliver materials. The work bridge is under construction, from the south shore, in this October 12, 1934, view. Survey work began on May 3, 1933, when B. A. Martin, Bishop Moorhead, Norman A. Mann, Willard Burdette, L. V. Reed, and R. A. Keasey arrived at temporary offices in the Newport City Hall. By the end of 1933, staff engineer Ivan Merchant and Oregon state bridge engineer C. B. McCullough had completed plans for the bridge. The estimated cost of right-of-way, location surveys, field engineering, and contract items was $1,380,457.25. Following approval of funding for what was known as Federal Public Works Project 982, the construction contract was awarded to Gilpin Construction Company of Portland, Oregon. (Courtesy ODOT.)

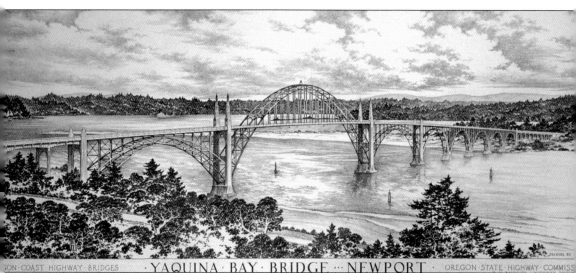

Oregon State Highway Department graphic artist Frank Hutchinson created this beautiful artistic rendition of Yaquina Bay Bridge for the purpose of promoting the Oregon coast bridges. The arrangement of the three steel arches and the five concrete arches is particularly graceful, enhanced by the pylons at the ends of the steel arches and adding elegance to an already spectacular setting. The bridge opened for traffic on Labor Day in 1936, and was dedicated on Saturday, October 3, 1936. Dedication festivities included a parade and banquet and featured two destroyers, a squadron of seaplanes, the 7th Infantry band, and a company of soldiers from Vancouver barracks. The 3,260-foot-long bridge has two 350-foot steel arches, one main 600-foot steel arch, five reinforced concrete arches spanning up to 265 feet, and reinforced concrete deck girder approaches. Construction removed 19,830 cubic yards of earth and consumed 54,000 cubic yards of gravel, 96,191 lineal feet of piling, 28,021 cubic yards of concrete, 2,192,269 pounds of reinforcing steel, and 3,819,051 pounds of structural steel. (Courtesy Oregon State Archives.)

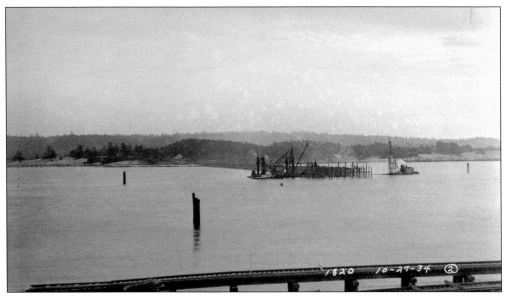

Gilpin began excavating as soon as they could get to the pier sites. This view shows the dredge *Coos* excavating for the pier that supports the south end of the main 600-foot steel arch span and the north end of the neighboring 350-foot steel deck arch span on October 27, 1934. The construction of Yaquina Bay Bridge eventually removed a total of 19,830 cubic yards of earth. (Courtesy ODOT.)

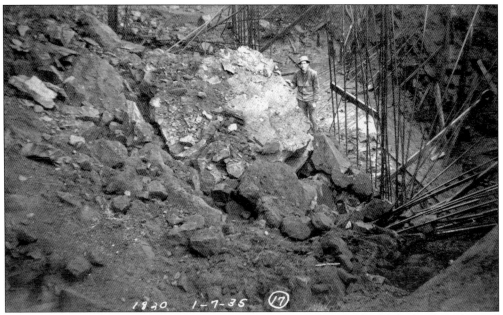

The Yaquina Bay Bridge site presented some challenges, including this landslide that bent the steel dowels installed to anchor the bridge pier into bedrock. A similar slide in early February partially covered worker Matt J. Huckler, who survived with broken ribs, cuts, and bruises. This January 7, 1935, view shows the site of the pier at the north end of the steel arches. (Courtesy ODOT.)

On Sunday, February 3, while playing in the north plaza construction area, 13-year-old George Kistemaker fell and landed on a one-inch square concrete reinforcing bar, which pierced his chest. According to the February 7, 1935, edition of the *Lincoln County Leader*, he was reported to be in the Lincoln Hospital in Toledo with a "fair chance for his life." (Courtesy ODOT.)

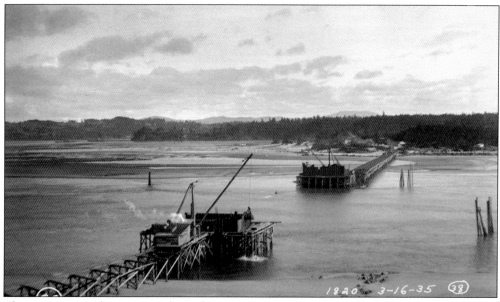

The main piers and navigation channel are pictured here on March 16, 1935, looking toward the southeast. The cofferdam at the pier south of the navigation channel was chronically leaky and eventually suffered a dangerous "blow-in," possibly the site of Ivan Merchant's reported harrowing escape from a failing cofferdam. During design of the Yaquina Bay Bridge, Ivan Merchant was responsible for structural calculations and sizing of structural members. (Courtesy ODOT.)

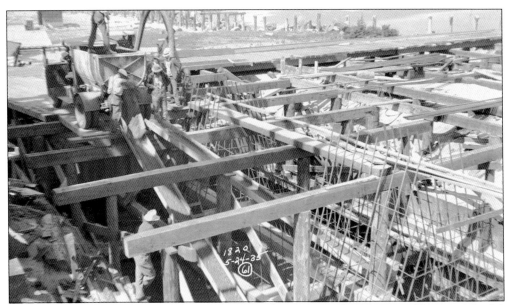

A concrete pour in a pier for one of the reinforced concrete arches is pictured here on May 24, 1935. Gilpin utilized trucks to haul the mixed concrete to the pier and chutes to put the concrete in the pier. The construction of Yaquina Bay Bridge consumed 28,021 cubic yards of concrete. The arch spans are deck arches, a bridge structure type with arch ribs below the roadway deck. (Courtesy ODOT.)

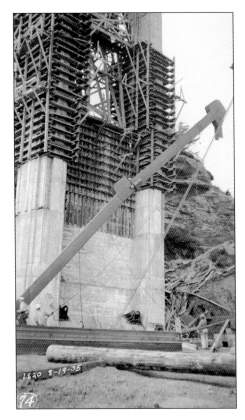

The first piece of structural steel is being put in place on August 19, 1935, at the north end of the steel arch spans. This piece was the beginning of a total 3,819,051 pounds of structural steel in the bridge. Forms have not yet been removed from the upper portions of the pier. (Courtesy ODOT.)

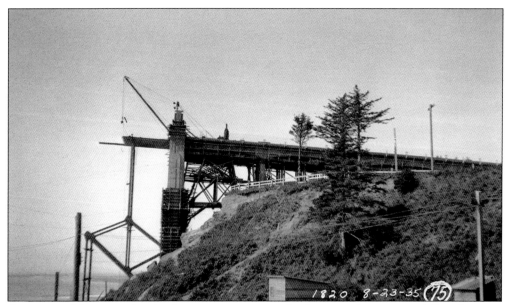

A portion of the trussed arch rib, supporting a pair of columns and a section of floor framing, was in place by August 23, 1935. Also pictured are the reinforced concrete deck girder north approach spans, a type of construction with girders and deck slab cast integrally, with forms and supporting falsework in place, and Gilpin's hoisting rig powered by a steam donkey engine. (Courtesy ODOT.)

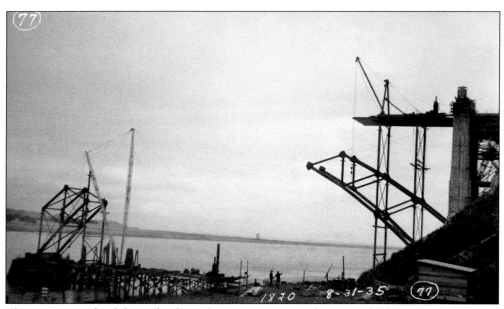

There was enough of the arch rib in place to support another pair of columns and additional floor framing on August 31, 1935, and the south end of the arch rib was progressing. Gilpin's hoisting rig has advanced onto the floor framing, and the temporary supports for the arch ribs are visible. (Courtesy ODOT.)

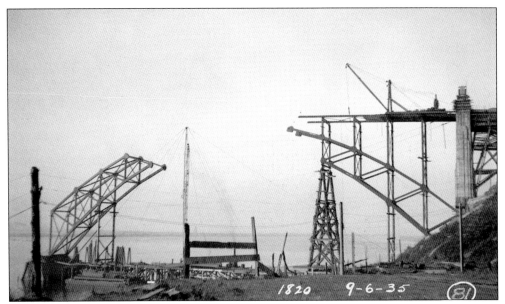

The arch ribs are growing toward their crown in this view dated September 6, 1935. There is a new, substantial-looking support under the north part of the arch rib, four pairs of columns are now in place, and the floor framing is extending steadily toward the south. Columns and floor framing are not being built atop the south piece of arch rib yet. (Courtesy ODOT.)

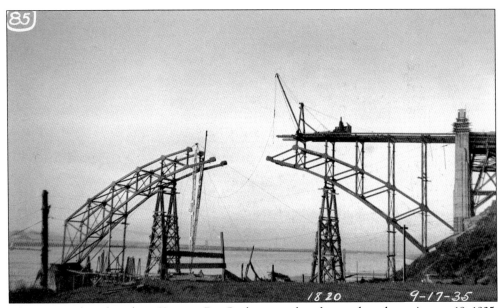

The structural steel work on Yaquina Bay Bridge started at the north arch on August 19, 1935. This view shows the north arch nearly connected less than a month later. Gilpin's hoisting rig can be seen on the bridge deck, and the temporary towers that support the partially completed arch are in place below. This photograph is dated September 17, 1935. (Courtesy ODOT.)

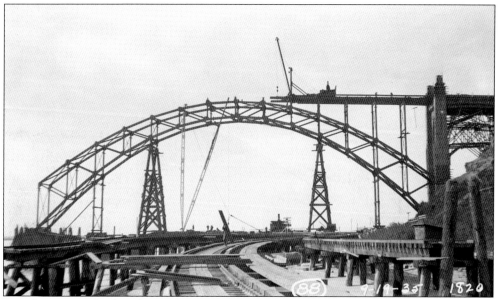

Exactly one month after placing the first structural steel, the arch rib is continuous, as pictured in this photograph dated September 19, 1935. The floor framing continues to extend southward, and Gilpin's crane is following the floor construction. The arch rib is now self-supporting, and the temporary support towers are unnecessary at this point. (Courtesy ODOT.)

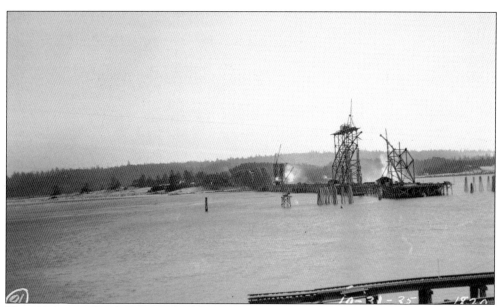

The 350-foot steel arch span south of the shipping channel was showing portions of the arch ribs on temporary supports by October 31, 1935, along with several pairs of columns, several sections of floor framing, and a hoisting rig on the floor. Some of the dolphins, pilings driven in a group and bundled together, are in place to protect the pier from marine traffic. (Courtesy ODOT.)

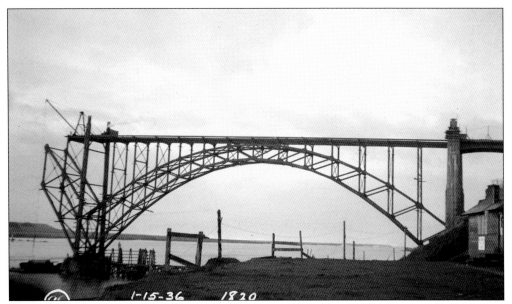

The arch ribs for the main 600-foot steel arch are starting to show in this January 15, 1936, view. One pair of columns is supporting a section of floor framing. The upper portions of the pier that support the south end of the 350-foot steel arch and the north end of the 600-foot steel arch have not been built yet; a temporary support is in place. (Courtesy ODOT.)

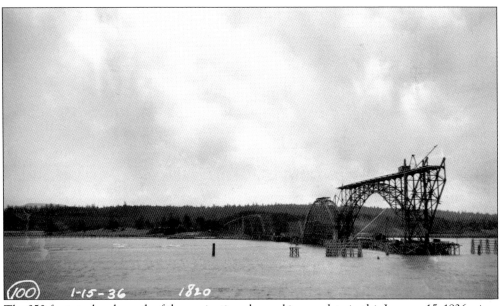

The 350-foot steel arch south of the navigation channel is complete in this January 15, 1936, view. At this point, the arch ribs at the south end of the main 600-foot steel arch are more complete than those at the north end. Also visible is the reinforced concrete arch construction south of the 350-foot steel arch. (Courtesy ODOT.)

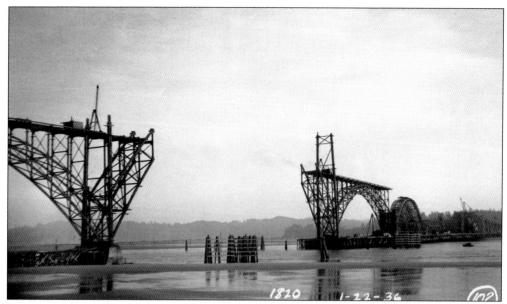

Portions of the steel arch ribs on the 600-foot steel arch are protruding above the floor framing on January 22, 1936. In this view looking southeast, a tower has been erected above the pier south of the navigation channel. Cables were rigged over this tower to support the arch rib as it proceeded upward. (Courtesy ODOT.)

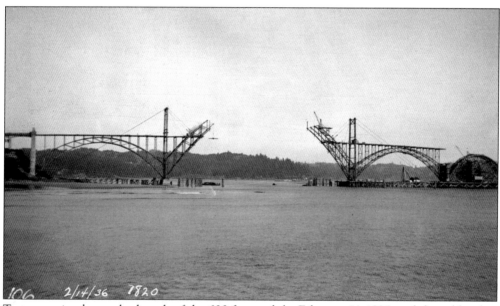

Towers are in place at both ends of the 600-foot arch by February 14, 1936, and the cables that support the upper portions of the arch ribs are visible. These cables are tied back to the base of the nearest pier. The arch ribs are reaching higher, and there is a platform and a hoisting rig on top of the south portion of the arch rib. (Courtesy ODOT.)

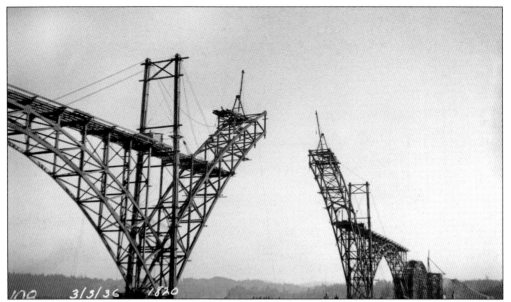

The towers at each end of the 600-foot steel arch are clearly visible in this March 3, 1936, view looking toward the southeast. Platforms and derricks are visible on top of both portions of the arch rib, and the steam donkey engines that power the hoisting rigs are on the floor at the towers. (Courtesy ODOT.)

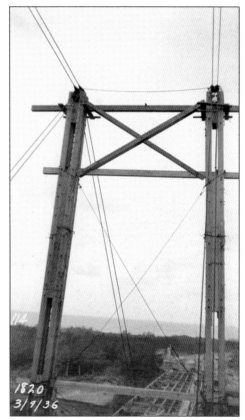

The tower at the north end of the 600-foot steel arch is pictured here on March 9, 1936. The tower was temporary and would be removed when the 600-foot arch ribs were connected at their crown. Each leg of the tower appears to be assembled from four heavy timbers. (Courtesy ODOT.)

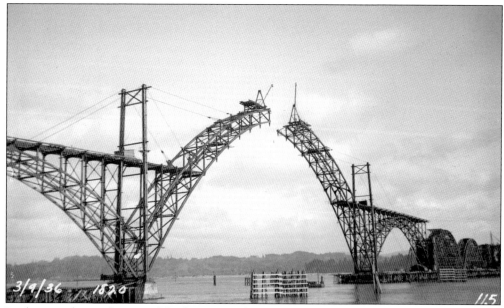

Looking to the southeast on March 9, 1936, the 600-foot steel arch ribs are nearly ready to be connected, and the platforms and derricks have been moved into their final positions. The steady progress of the reinforced concrete deck arch construction south of the steel arches is visible to the right. (Courtesy ODOT.)

The connections of temporary support cables to the top of the 600-foot steel arch rib are pictured here on March 10, 1936, looking east. The lower cable is tied directly to the structure and the rest go through sheaves or pulleys attached to the top of the arch rib. (Courtesy ODOT.)

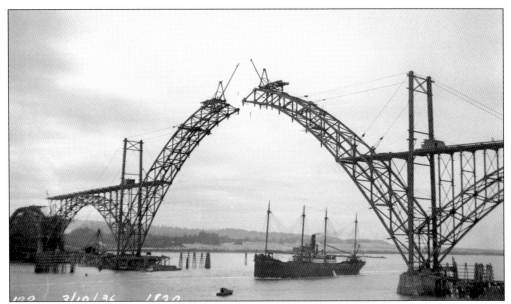

The steamer *Anna Schafer* passes below the 600-foot steel arch span on March 10, 1936, demonstrating why the roadway is so high above the bay. The north and south parts of the arch ribs are ready for the final pieces of structural steel that will connect them and make the arch continuous. (Courtesy ODOT.)

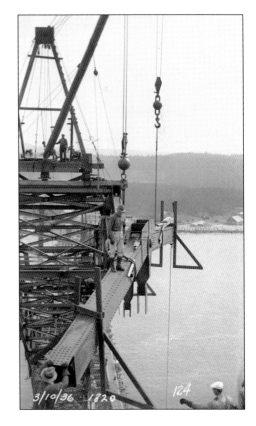

The last pieces of arch rib structural steel were placed to make the 600-foot steel arch continuous on March 10, 1936. This section of steel was being hoisted by the two derricks with plenty of workers on hand. Presumably the man on the steel was there to monitor both ends of the beam as it was being placed. (Courtesy ODOT.)

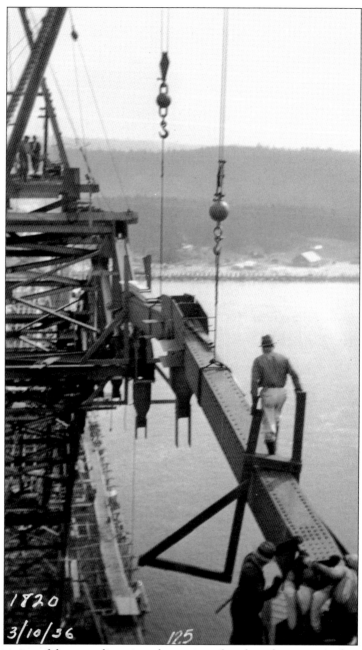

In this continuation of the preceding view, the section of steel was being set in place by lines from the two derricks located near the center so the steel would not tend to roll over. The structural steel workers normally did not work on windy days; they had little of the safety equipment taken for granted today. By comparison, the concrete workers worked during the windy days when the steel workers did not, and the one known fatality during the construction of Yaquina Bay Bridge occurred when laborer Ted McDaniel fell from the falsework of the south reinforced concrete deck arch spans on a windy day, July 22, 1936. The bridge has a total of three steel spans, a 350-foot deck arch near the north end, the main 600-foot arch over the navigation channel, and another 350-foot deck arch south of the main arch. (Courtesy ODOT.)

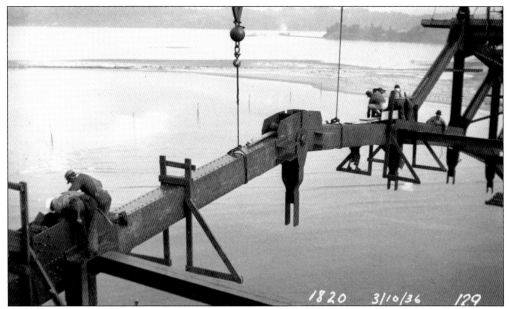

Once the section of steel was set in place, workers began attaching it to the arch ribs. Near each end of the 50-foot-long piece of steel was a temporary bracket. These brackets kept the steel from tipping over during handling, preventing damage to the connection that hangs from the center. (Courtesy ODOT.)

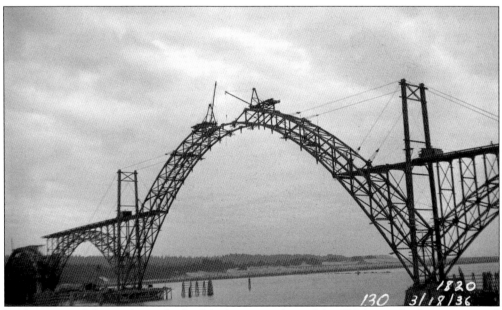

Looking toward the southwest, both of the lower members of the 600-foot arch rib are connected in this March 18, 1936, photograph. The arch will be complete with the addition of two upper members, posts, and bracing. The American Bridge Company fabricated the structural steel for Yaquina Bay Bridge. (Courtesy ODOT.)

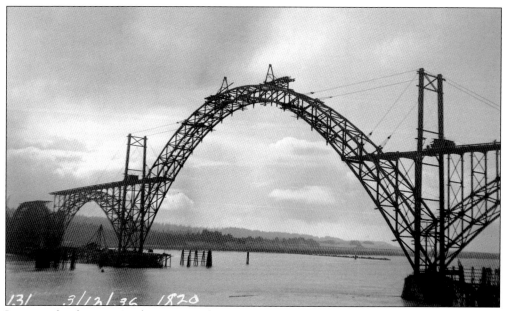

Later in the day on March 18, 1936, the upper members of the arch rib are now connected, and the arch is continuous. Construction of the 600-foot arch was started a mere two months earlier. The towers at the two main piers and the derricks and platforms could now be removed. (Courtesy ODOT.)

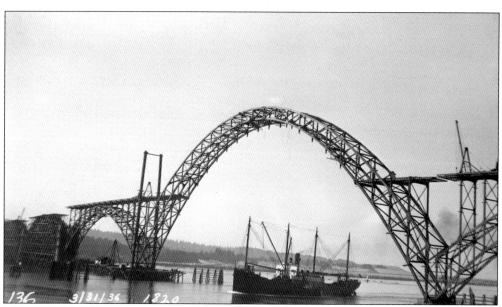

The steamer *Timberman* passes beneath the newly continuous 600-foot steel arch on March 31, 1936. The temporary support cables are gone, the temporary tower on the pier at the north side of the navigation channel has been removed, and the temporary tower at the south side has been partially dismantled. (Courtesy ODOT.)

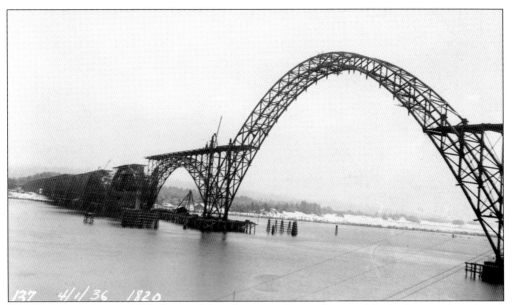

On April Fool's Day in 1936, the south beach area to the southwest of the bridge was dusted with snow. Snow is unusual on the Oregon coast, and in April, it would only be considered normal in the mountains. The temporary tower on the pier at the south side of the navigation channel has been moved down to roadway level. (Courtesy ODOT.)

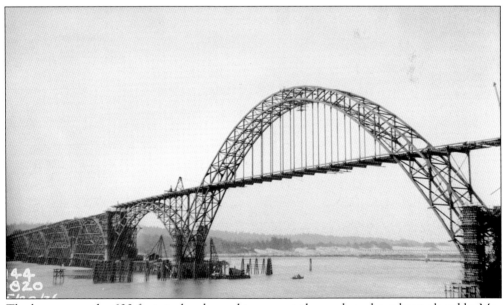

The hangers on the 600-foot steel arch, used to support the roadway, have been placed by May 22, 1936, and the floor framing appears complete. The formwork for the piers at each end of the 600-foot arch appears partly completed. Gilpin completed most of the 600-foot steel arch span's steel erection in just over four months. (Courtesy ODOT.)

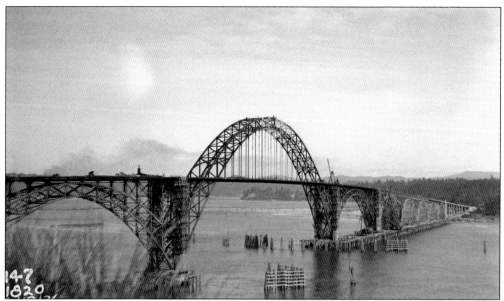

The 350-foot and 600-foot steel arch spans have been partially painted green. The formwork for the piers at each end of the 600-foot arch extends up to the roadway level in this June 19, 1936, view looking toward the southeast. The reinforced concrete arch spans are still being constructed and the reinforced concrete deck girder approach spans to the south appear complete. (Courtesy ODOT.)

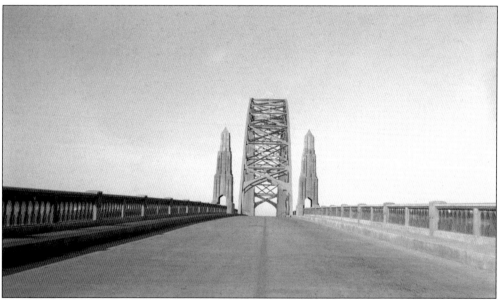

The roadway view of the bridge is pictured here on November 17, 1936. An aviation light on top of the bridge failed regularly during the first year of use, and state maintenance forces paid a local citizen $10 to climb the bridge to replace the light bulb each time it went out. Maintenance requested a $450 ladder, but it was opposed by C. B. McCullough for aesthetic reasons and was not built. (Courtesy ODOT.)

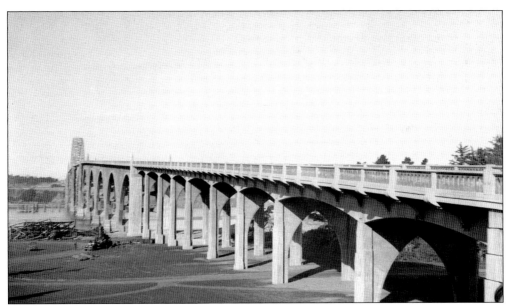

The reinforced concrete deck girder south approach spans are seen in this November 17, 1936, photograph of the completed bridge, looking toward the northeast. The bottom surface of the girders was given a shallow arch shape to better blend in with the arch spans. When viewed in a line, the Gothic-style arched openings in the supporting bents are reminiscent of the roof framing of European cathedrals. (Courtesy ODOT.)

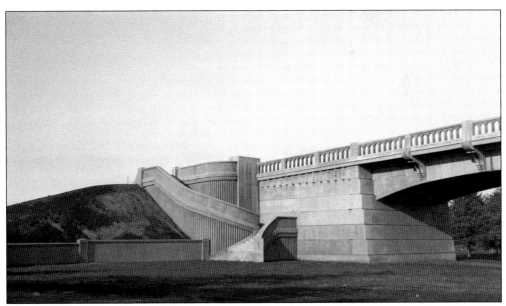

Each end of the bridge has a pedestrian plaza with stairways leading up to the sidewalks on the bridge. This November 17, 1936, view shows the south plaza with its very elaborate curved stairways, handrails, walls, and patterns of "streamlined" art deco and Moderne-style vertical and horizontal lines. Additional architectural features are seen in the Gothic-style arch handrail and graceful curved brackets supporting the sidewalk beneath each rail post. (Courtesy ODOT.)

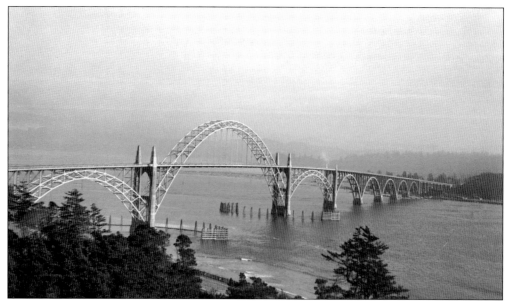

This photograph shows the overall appearance of the bridge from the northwest on November 17, 1936, 25 months after the start of construction. This bridge was designed in a short six months by Oregon State Highway Department staff working two shifts. During the same six months, the staff also completed designs for four other large coastal bridges. (Courtesy ODOT.)

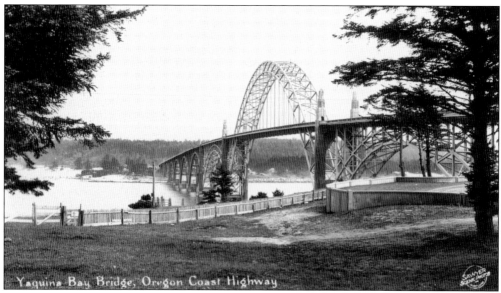

This photograph by Sawyers of Portland shows the newly completed Yaquina Bay Bridge from the northeast. The total cost of the 3,260-foot-long bridge was $1,260,621.90, less than the $1,380,457.25 engineer's estimate. Construction of this bridge employed an average of 220 men on 30-hour weeks with an average payroll of $5,000 per week. (Courtesy author.)

Three

ALSEA BAY BRIDGE (WALDPORT)

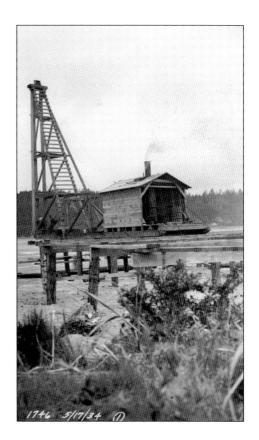

A steam pile driver begins driving pilings for the contractor's work bridge at Alsea Bay in this photograph dated May 17, 1934. The United States War Department had objected to the original proposed design, which had only one opening for marine traffic, a single reinforced concrete tied arch. So C. B. McCullough and his designers raised the vertical clearance from 50 feet to 70 feet and added two more tied arch spans. A tied arch is a bridge structure type with arch ribs above roadway level, which uses the deck as a "tie" to resist the horizontal thrust of the arch ribs. The original engineer's estimate of $685,040 was increased before award of the contract to account for "several expensive revisions to foundations on this job." The $778,260.73 contract for construction of the bridge was awarded on April 26, 1934, to Lindstrom and Feigenson, Parker and Banfield, and T. H. Banfield—a joint venture. (Courtesy ODOT.)

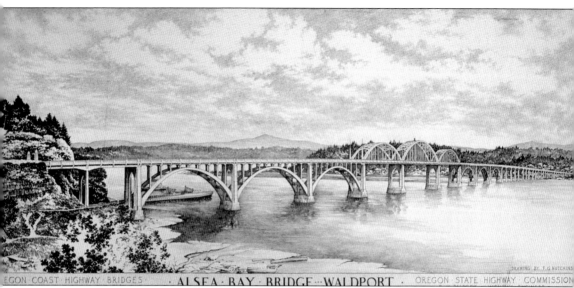

Oregon State Highway Department graphic artist Frank Hutchinson created this beautiful artistic rendition of Alsea Bay Bridge for the purpose of promoting the Oregon coast bridges. The reinforced concrete deck arches and tied arches were well proportioned, enhanced by tiered spires at the ends of the tied arches. The bridge sported ornate art deco and Moderne-style detailing typified by the fluted and tiered bents supporting the reinforced concrete deck girder approaches. During the dedication ceremony for the bridge, R. H. Baldock of the Oregon State Highway Department said that Alsea Bay Bridge and the other four bridges built at the same time were "set like jewels in a chain of incomparable beauty" and that they "have been built to withstand the winds, the currents, and the tides of the centuries." The Oregon Coast Highway was finally complete from the Columbia River to the California border after 22 years under construction. (Courtesy Oregon State Archives.)

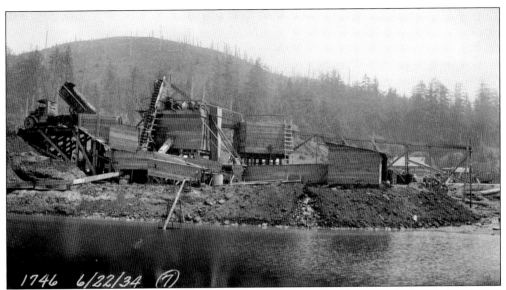

1746 6/22/34 ⑦

Some, if not all, of the gravel for Alsea Bay Bridge came from this gravel plant belonging to Saxton and Looney, which was located at the mouth of Ten Mile Creek. The gravel plant, with an assortment of conveyors, chutes, bins, and ladders, is pictured in operation on June 22, 1934, fed by a heavy-duty dump truck. (Courtesy ODOT.)

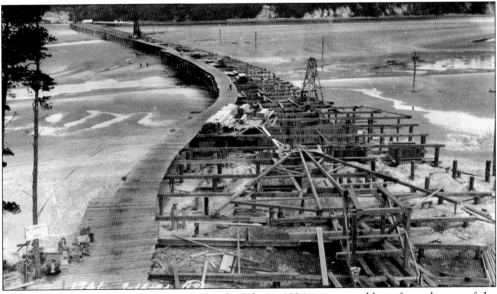

The work bridge extended far into the bay by July 14, 1934, as pictured here from the top of the joint venture's concrete plant. Work has been started on the foundations for the approach spans. Construction of a reinforced concrete bridge required a massive amount of timber, as suggested by this view. (Courtesy ODOT.)

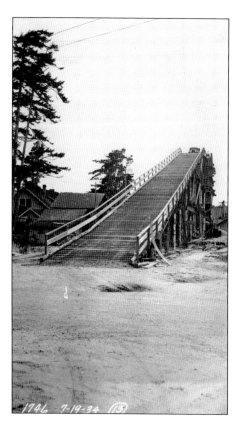

The ramp to the joint venture's concrete plant is pictured here on July 19, 1934, with a truck at the top. The ramp has a wooden plank deck, wooden rails, and a challenging 25 percent grade. The noise and dust must have been disturbing to the people living in the nearby house. (Courtesy ODOT.)

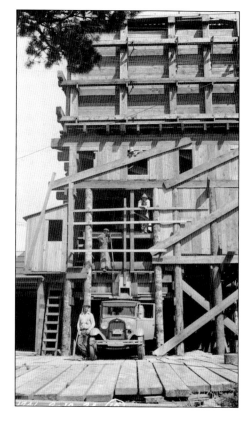

The joint venture's concrete plant is seen here in operation in this August 10, 1934, photograph. The concrete plant is equipped with two 14S mixers and Johnson batch-weighing devices. A 1928 or 1929 Ford Model AA truck is being loaded with concrete. Construction of Alsea Bay Bridge required a total of 12,298 cubic yards of concrete. (Courtesy ODOT.)

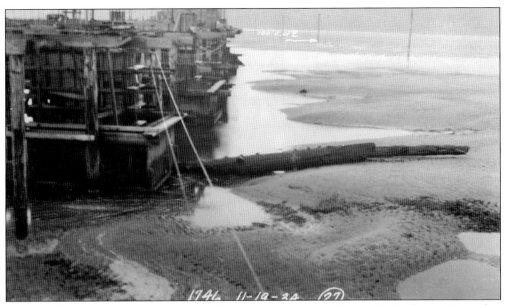

Scour, or loss of streambed material to flowing water, was noted near the bridge on November 19, 1934. This view looking northward on the east side of the bridge shows the scour and a large piece of driftwood. Scour is currently the most common cause of bridge failure in the United States. (Courtesy ODOT.)

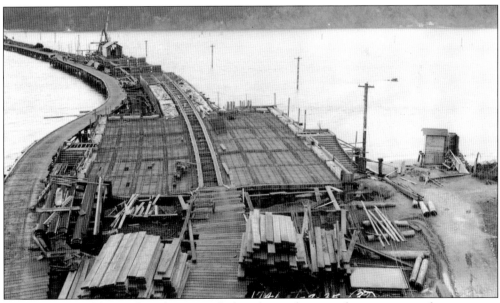

Forms for some of the reinforced concrete deck girder south approach spans, a type of construction with girders and deck slab cast integrally, are seen in this January 7, 1935, photograph. Also pictured was a portion of deck forms and stairways for the south approach entrance. At the end of the forms, a derrick was erecting falsework, the temporary structure that supported the forms. (Courtesy ODOT.)

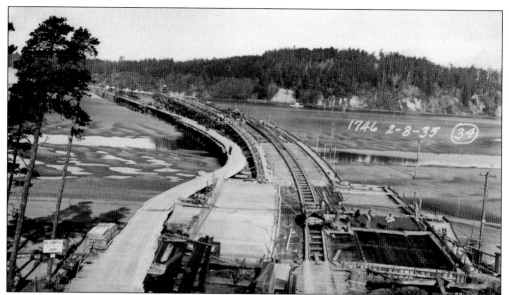

A portion of the south approach entrance deck has been poured by February 8, 1935, and the forms and falsework have advanced far into Alsea Bay. Materials were delivered on a track along the center of the new bridge. Concrete workers were busy at the right portion of the south approach entrance deck. (Courtesy ODOT.)

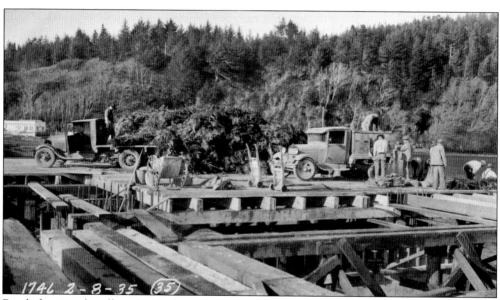

Brush fascines, bundles of sticks bound together, are being placed around the foundation of a pier to help protect it from the scouring effect of flowing water on February 8, 1935. The fascines were sunk using bagged concrete. The truck at left is a 1928 Ford Model AA, and the truck at right is a 1929 Ford Model AA. (Courtesy ODOT.)

During placement of riprap at Alsea Bay Bridge, a failure of the work bridge deck caused G. P. Hunter's truck to fall into the bay. Riprap is heavy rock that is placed around the pier to protect it from the scouring effect of tides or rivers, which tends to undermine bridge piers. (Courtesy ODOT.)

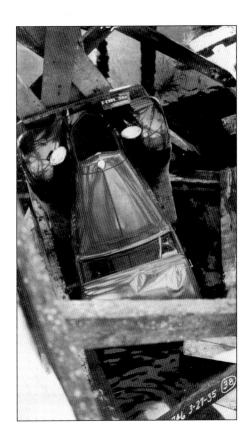

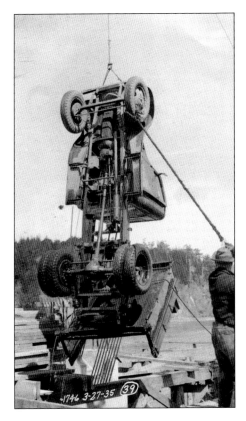

G. P. Hunter's truck was recovered by one of the joint venture's hoisting rigs on March 27, 1935. The truck had fallen into Alsea Bay while placing riprap. The hoisting rig's line was attached to the front of the truck's frame, and a second line was attached to a front wheel to keep the truck from twisting. (Courtesy ODOT.)

This is another view of the recovery of G. P. Hunter's truck from Alsea Bay on March 27, 1935. The dump truck appears to be a nearly new 1934 or 1935 Chevrolet. The fate of the truck after recovery is not known, but the corrosive effects of saltwater immersion were likely severe. (Courtesy ODOT.)

The joint venture's formwork and falsework framing yard is pictured here on April 9, 1935. Layout for one of the deck arches, the arch spans that support the roadway deck from below, was set up on a wooden platform. Once the layout was verified to be correct, it was used to build arch rib forms and falsework to the proper dimensions. (Courtesy ODOT.)

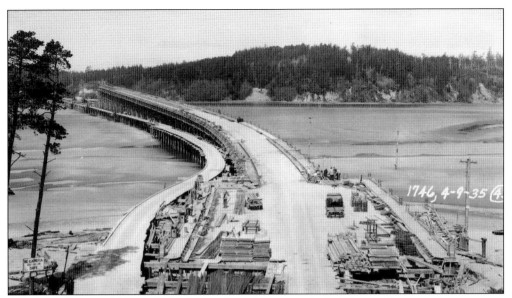

All of the forms and falsework for the reinforced concrete deck girder south approach spans were in place by April 9, 1935, and much of the deck and sidewalk concrete had been poured. The track along the center of the bridge appears to have been moved ahead with the concrete pours. (Courtesy ODOT.)

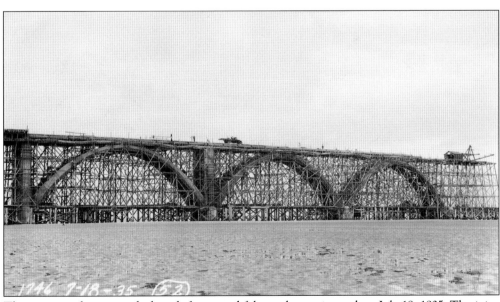

Three spans of concrete deck arch forms and falsework are pictured on July 18, 1935. The joint venture's derrick is working on the falsework for one of the tied arches, the spans with the arch ribs above roadway level, and a truck is delivering lumber atop the falsework. Deck arches are a bridge structure type with arch ribs below the roadway deck. (Courtesy ODOT.)

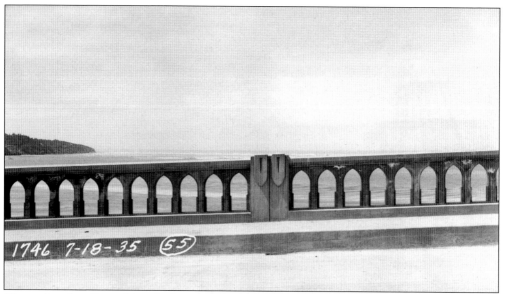

The curb, sidewalk, and handrail are pictured here on July 18, 1935, looking toward the Pacific Ocean. The handrail was very important architecturally, as the motoring public often saw more of it than the actual structure of the bridge. This handrail features openings between the balusters, or pickets, shaped like stylized Gothic arches. (Courtesy ODOT.)

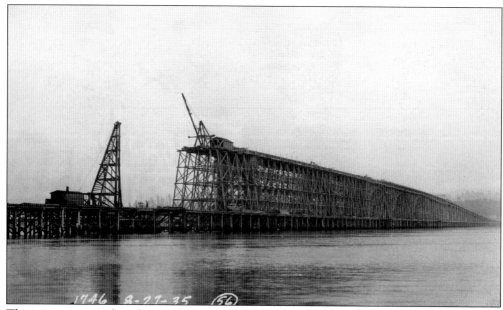

The joint venture's derrick is working on falsework for the tied arch spans in this view looking southwest from the north shore of Alsea Bay on August 27, 1935. A hoisting rig is visible at left of the view, and within the falsework, the forms for the piers that support the tied arches are being built. (Courtesy ODOT.)

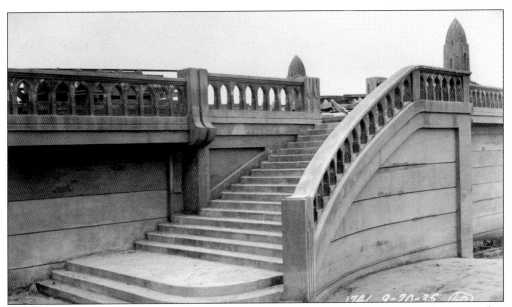

The south end of the bridge had stairways leading up to the sidewalks on the bridge. This September 20, 1935, view shows the east stairway at the south approach entrance with its elaborate curved stairway, handrails, walls, and "streamlined" horizontal patterns. Also pictured are two of the highly decorated entrance pylons. (Courtesy ODOT.)

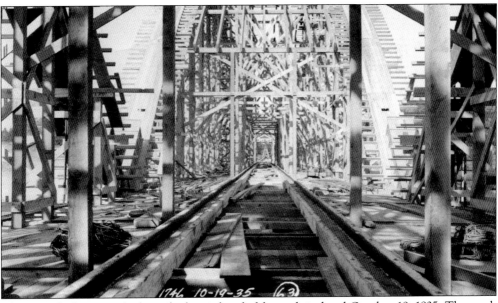

This view looking north through the tied arch falsework is dated October 19, 1935. The track along the center of the bridge is clearly visible along with extensive falsework to support the arch rib forms. The main span was a 210-foot tied arch, flanked by a 154-foot tied arch on each side. (Courtesy ODOT.)

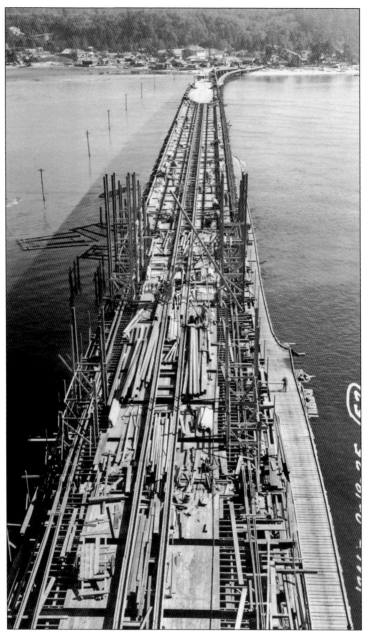

The joint venture used an industrial tower to erect the falsework and forms for the tied arches. This view was taken from the industrial tower, looking south, on September 19, 1935. The track is set up to deliver materials along the center of the bridge. Work on the upper portion of falsework has begun, with a number of vertical timbers standing up to support the arch rib forms. As pictured, the work bridge is wider at the tied arch spans. When the bridge was completed, its overall length was 3,028 feet, with three tied arches at the navigation channel, three 150-foot reinforced concrete deck arches on each side of the navigation channel, and reinforced concrete deck girder approaches. Construction of the bridge removed 8,973 cubic yards of soil and consumed 19,298 cubic yards of concrete, 71,806 lineal feet of piling, 1,884,423 pounds of reinforcing steel, and 265,204 pounds of structural steel. (Courtesy ODOT.)

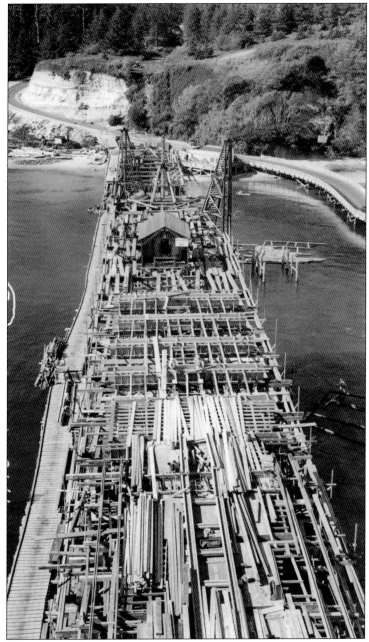

This view looking toward the north was taken from the industrial tower, used to erect the falsework and forms for the tied arch spans, on September 19, 1935. A portion of the track along the center of the bridge was in place, and the hoisting rig pictured on page 56 was visible. From this view and the photograph on page 58, it is apparent that few, if any, vessels or other marine traffic passed up or down Alsea Bay during the construction of the Alsea Bay Bridge. At upper right, the approach to the nearly obsolete ferry landing is visible. Below this vantage point one can see the construction of the 210-foot reinforced concrete tied arch, the largest in the state of Oregon. Staff engineer Claude Darby prepared the plans for state bridge engineer C. B. McCullough. (Courtesy ODOT.)

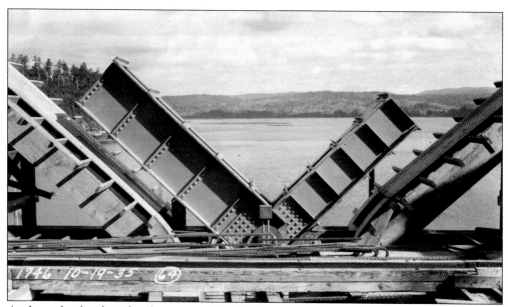

At the ends of each tied arch, structural steel stubs were cast into the concrete arch ribs to help transfer the arch rib loads to the pier and deck. Looking east on October 19, 1935, the structural steel stubs, with the 210-foot tied arch at left and the 154-foot tied arch at right, are pictured. (Courtesy ODOT.)

This November 20, 1935, photograph shows a Considère hinge at the crown of one of the 150-foot deck arches. French engineer Armand Considère's hinge "necked down" the section of the arch rib to make it flexible and thereby minimize built-in bending stresses. When the arch was supporting the full weight of the bridge, the hinge was reinforced and filled with concrete. (Courtesy ODOT.)

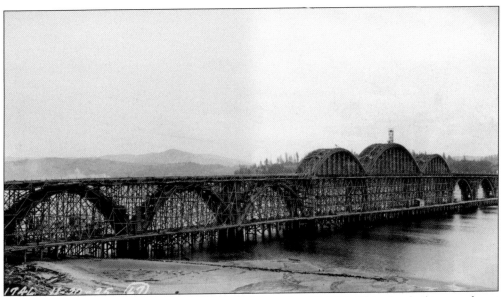

The shape of the bridge was becoming visible by November 20, 1935. This view looking southeast from the north shore of Alsea Bay shows the forms and falsework for the north deck arches and the tied arches in place and the south deck arches with the falsework and some forms removed. (Courtesy ODOT.)

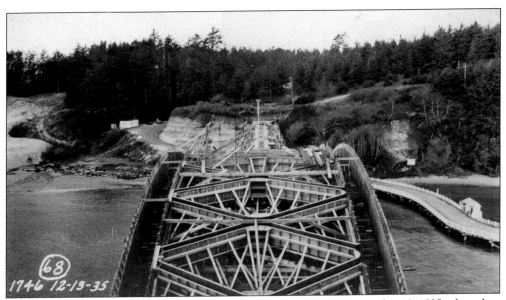

This is how the forms for the north 154-foot tied arch appeared on December 13, 1935, when they were viewed from the top of the 210-foot tied arch. The forms for the diagonal bracing between the arch ribs are clearly visible as is the approach to the north ferry landing. (Courtesy ODOT.)

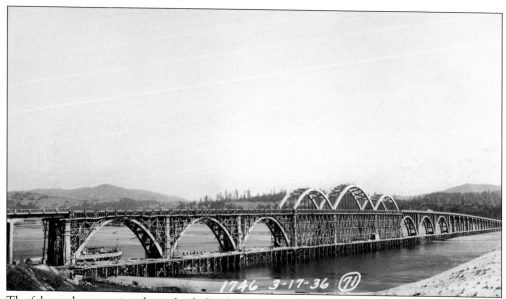

The falsework supporting the arch ribs has been removed from both the deck arches and the tied arches, and forms have been removed from the arch ribs in this March 17, 1936, view looking southeast from the north shore of Alsea Bay. The falsework supporting the deck slabs is still in place on most of the arches. (Courtesy ODOT.)

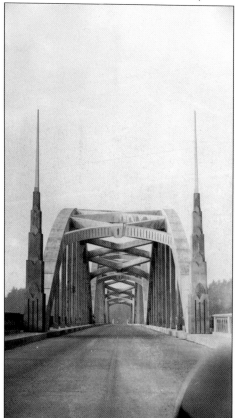

This roadway view of the completed bridge shows the tied arches and the tall streamlined entrance pylons with spires. The Alsea Bay Bridge was unusual in that it had a 24-foot-wide roadway and a 31-foot overall width, while the other large coastal bridges had a 27-foot-wide roadway and a 37-foot overall width. (Courtesy ODOT.)

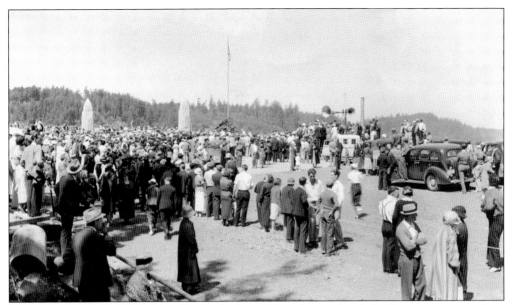

Dedication festivities at the Alsea Bay Bridge lasted three days and included boat races, a marathon Alsea Bay swim, a track-and-field meet, an "oceanside jamboree," a ladies softball game between Corvallis and Waldport, fireworks, a fly-casting exhibition by the Portland Casting Club, an aquatic circus, dances, and swimming and diving exhibitions. The May 9, 1936, dedication ceremony featured Gov. Charles H. Martin as principal speaker. (Courtesy ODOT.)

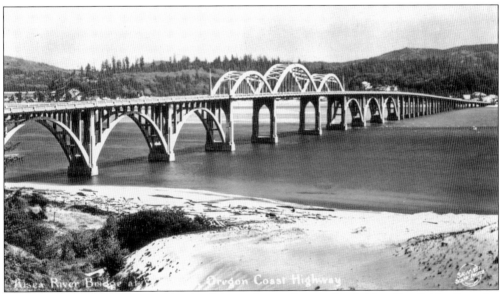

This photograph by Sawyers of Portland shows the newly completed Alsea Bay Bridge from the northwest. The total cost of the 3,028-foot-long bridge was $746,762.28. Construction of this bridge employed an average of 150 men on 30-hour weeks with an average payroll of $3,000 to $4,000 per week. (Courtesy author.)

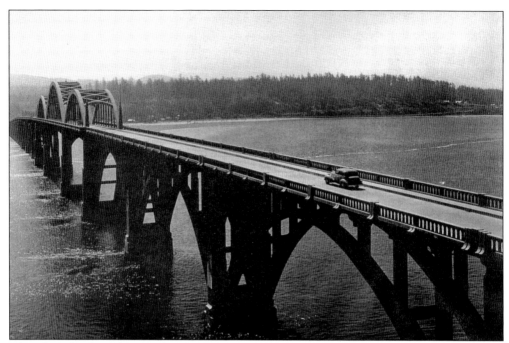

This photograph of the completed Alsea Bay Bridge by photographer Cecil Ager shows a lone automobile crossing the bridge. The impact of the Oregon coast bridges on coastal travel was dramatic, easing everyday trips for local residents as well as regional freight movement and helping to open the Oregon coast for recreation and tourism. (Courtesy Carol Thilenius.)

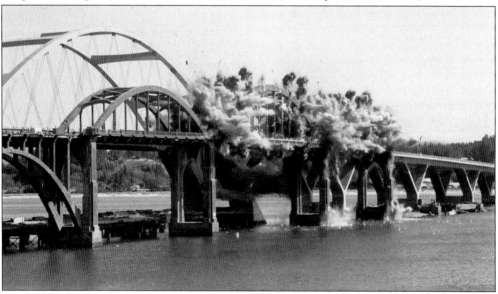

The Alsea Bay Bridge suffered from severe damage due to corrosion of its steel reinforcing bars, which was noted as early as 1946. The bridge's condition deteriorated rapidly during the 1980s, requiring inspections on a weekly and monthly basis. In 1991, it was replaced by a new bridge costing $42.5 million. Pictured here is a scene from the October 1, 1991, demolition of the old bridge. The cost of demolition was $778,000—more than it cost to build the bridge 55 years earlier. (Courtesy ODOT.)

Four

SIUSLAW RIVER BRIDGE (FLORENCE)

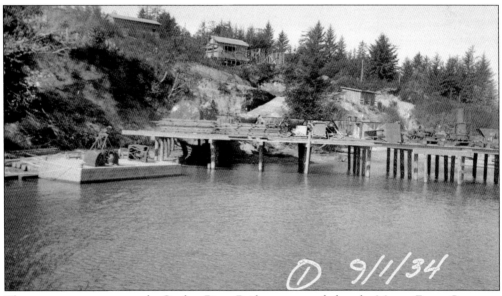

The contract to construct the Siuslaw River Bridge was awarded to the Mercer-Fraser Company of Eureka, California. Mercer-Fraser's first action was to build falsework, the structure used to support the forms for concrete, pictured here at the south bank of the Siuslaw River on September 1, 1934. The barge and the falsework are supporting a variety of heavy equipment that will be used in the construction. C. B. McCullough and his designers selected a bascule-type drawbridge for the low banks and single narrow navigation channel of the Siuslaw River. The 1,568-foot-long bridge has a double-leaf bascule draw span at the 140-foot-wide navigation channel, flanked by two 154-foot reinforced concrete tied arch spans, with reinforced concrete deck girder approaches, a type of construction with girders and deck slab cast integrally. A tied arch is a bridge structure type with arch ribs above roadway level and a double-leaf bascule is a drawbridge type that has two movable sections that hinge at the pier to open upward away from the navigation channel. (Courtesy ODOT.)

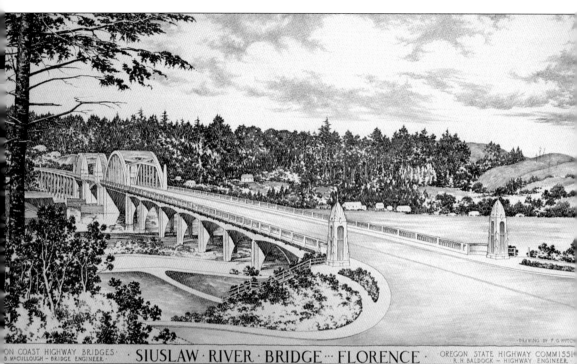

ON COAST HIGHWAY BRIDGES · · SIUSLAW · RIVER · BRIDGE ··· FLORENCE · ·OREGON STATE HIGHWAY COMMISSI
C. B. McCULLOUGH - BRIDGE ENGINEER · R. H. BALDOCK - HIGHWAY ENGINEER ·

Oregon State Highway Department graphic artist Frank Hutchinson created this beautiful artistic rendition of the Siuslaw River Bridge for the purpose of promoting the Oregon coast bridges. The concrete tied arches, the arched lower surface of the steel bascule spans, the arched facades of the concrete approach spans, and the large pylons and pier houses blend dissimilar structures to create a unique and graceful appearance. Art deco and Moderne-style detailing adorned the arches, pier houses, entrance pylons, piers, and reinforced concrete deck girder approaches. The 1,568-foot-long Siuslaw River Bridge opened to traffic on March 31, 1936. Construction of the bridge removed 4,960 cubic yards of soil and consumed 9,955 cubic yards of concrete, 38,902 lineal feet of piling, 1,011,689 pounds of reinforcing steel, and 584,776 pounds of structural steel. There were no fatal accidents during the construction of the Siuslaw River Bridge. (Courtesy Oregon State Archives.)

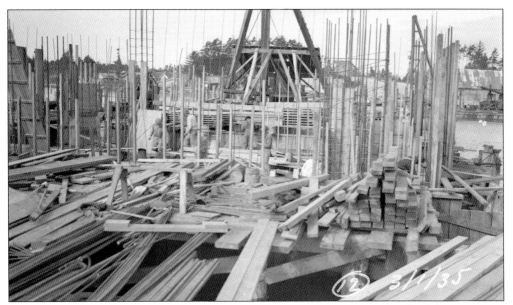

Mercer-Fraser's carpenters are building forms for the main pier on the south side of the navigation channel in this March 1, 1935, view looking north. A hoisting rig is visible on the opposite side of the pier and the town of Florence is visible beyond. Some of the steel reinforcing bars for the pier are sticking up above the formwork. (Courtesy ODOT.)

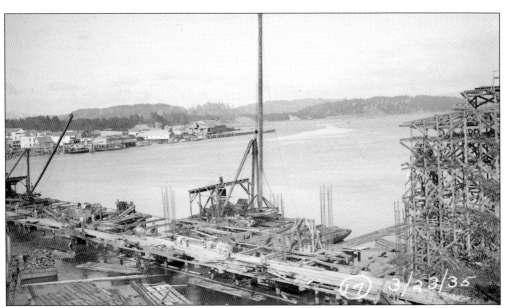

A cofferdam for one of the piers in the south approach is being pumped out on March 23, 1935. Also visible is a hoisting rig, powered by a steam donkey engine, riding on a barge and some tall falsework for the reinforced concrete deck girder south approach. Once the water was pumped out, the cofferdam provided access to the bottom of the pier. (Courtesy ODOT.)

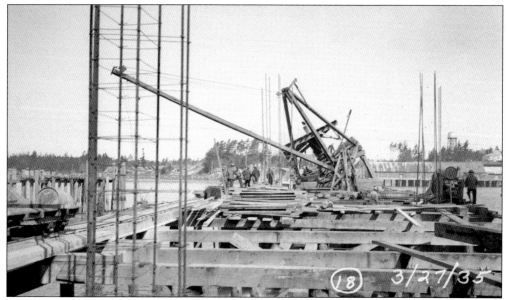

A hoisting rig tipped and dropped a 10-inch pump and engine into the river on March 27, 1935. Here the hoisting rig leans heavily while men examine the accident. This appears to be the same hoisting rig pictured on page 67, moved from the barge onto the falsework. (Courtesy ODOT.)

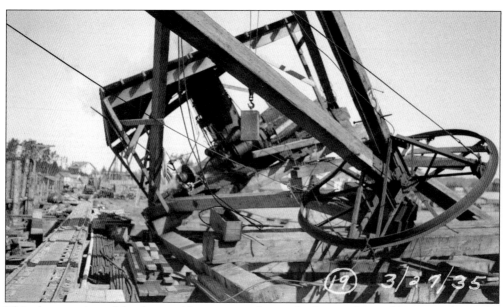

This close-up view of the damaged hoisting rig shows a broken timber and bent circular guide, also on March 27, 1935. Also pictured is damage to the supports for the shed roof over the steam donkey engine. At left is a railway used to move materials and equipment within the bridge site. (Courtesy ODOT.)

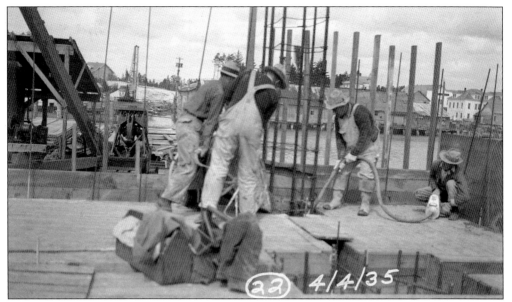

Looking north, concrete workers place concrete with a vibrator in the main pier on the south side of the navigation channel on April 4, 1935. Construction of the Siuslaw River Bridge consumed 9,955 cubic yards of concrete. At left in this view is one of Mercer-Fraser's hoisting rigs, possibly the same as the one pictured on page 68. (Courtesy ODOT.)

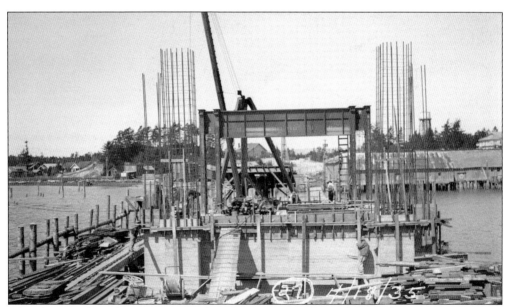

This photograph of the main pier south of the navigation channel shows the pier with the forms removed to 14 feet above sea level on April 18, 1935. The structural steel will support the south bascule leaf, one of the movable sections of bridge that hinge at the piers to open upward away from the navigation channel. (Courtesy ODOT.)

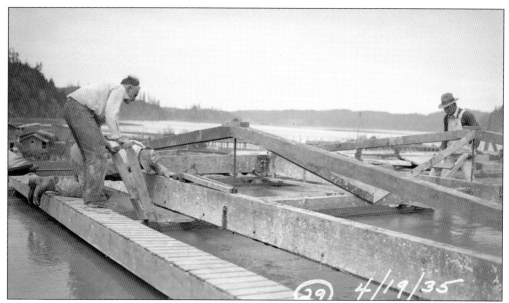

Mercer-Fraser used this method to screed the deck concrete. Screeding is a concrete finishing operation that establishes a flat surface at the required height and works the wet concrete, accomplished in this case by the standing workers pushing a timber back and forth between them and slowly advancing toward the other worker. The large frame controls the height of the timber. This photograph is dated April 19, 1935. (Courtesy ODOT.)

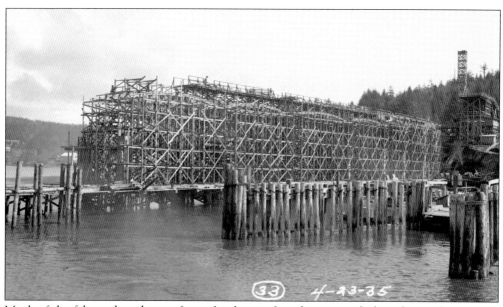

Much of the falsework and some forms for the reinforced concrete deck girder south approach were in place by April 19, 1935. At upper right is Mercer-Fraser's concrete plant, and at lower right is the ferry landing lined with dolphins, pilings driven in a group and bound together. (Courtesy ODOT.)

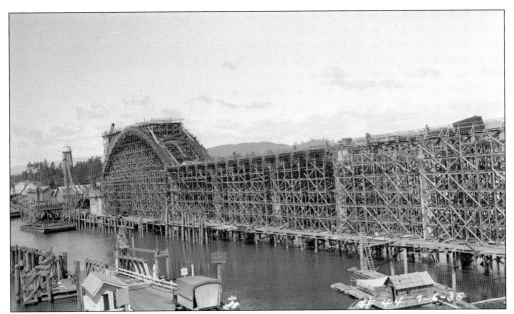

The south arch ribs have been poured up to the level of the first braces on July 6, 1935, and Mercer-Fraser was beginning to remove forms from the reinforced concrete deck girder south approach spans. At lower left is the ferry landing and its tollbooth with a vehicle waiting to cross. (Courtesy ODOT.)

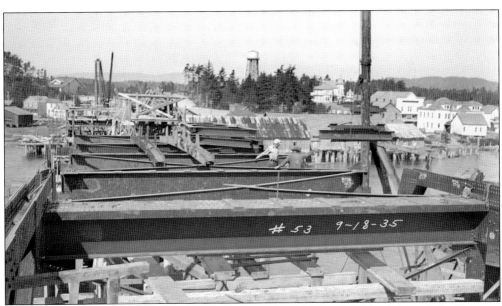

Workers are assembling the south bascule leaf on September 18, 1935. Each bascule leaf has two steel trusses with floor beams transversely mounted atop the trusses. Steel stringers, parallel with the trusses, are attached to the top of the floor beams, and the deck is mounted on the stringers. (Courtesy ODOT.)

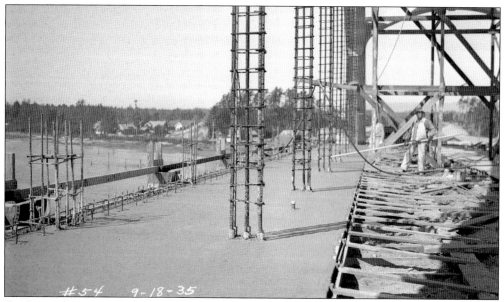

On September 18, 1935, the concrete worker in this photograph is finishing the sidewalk on the south arch. At left is the reinforcement for a handrail post, at center is reinforcement for the hangers that support the deck from the arch ribs, and at right are the braces that stabilize the sidewalk forms. (Courtesy ODOT.)

The wrong stringers were installed over the main pier south of the navigation channel, resulting in an excessive gap between the movable section at right and the fixed section at left. The fixed section was to receive a reinforced concrete deck later during construction. This photograph was taken October 8, 1935. (Courtesy ODOT.)

This steam donkey engine fell into a cofferdam at the north end of the bridge on October 21, 1935. The state project inspector reported that the "beam line" failed on a pile driver being used as a crane. The water level is close to the engine, and the workers are hurrying to retrieve it before the tide rises or the engine falls in deeper. (Courtesy ODOT.)

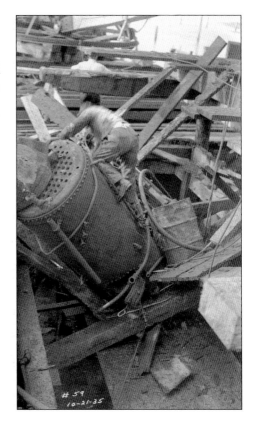

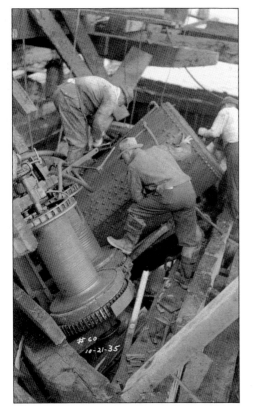

Several workers are preparing to retrieve the fallen steam donkey engine from the cofferdam in this October 21, 1935, view. It appears that the heavy timber shoring, which helps the cofferdam to resist the hydrostatic pressure of the water around it, probably kept the heavy engine from falling deeper into the cofferdam. (Courtesy ODOT.)

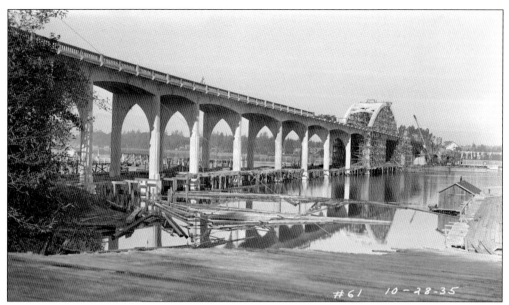

The reinforced concrete deck girder south approach spans appear complete in this view from the south shore on October 28, 1935. The bascule spans are in place, and the south arch appears nearly complete, but its falsework has not been removed. The Gothic-style arch openings in the supporting bents are visible. (Courtesy ODOT.)

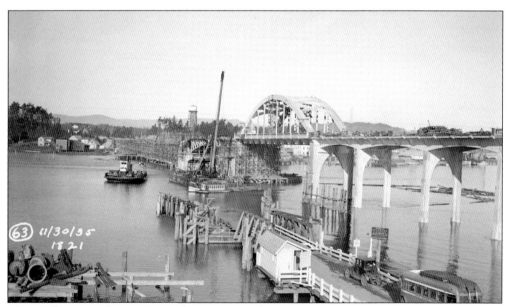

The Siuslaw River ferry is pictured in operation, looking northeast toward the town of Florence on November 30, 1935. An automobile and a bus are waiting at the ferry landing and tollbooth. Falsework is being removed beneath the south arch span, and not much of the north arch span is visible yet. (Courtesy ODOT.)

74

Workers are placing and attaching five-inch-thick Port Orford cedar decking on stringers on the bascule spans on November 30, 1935. Workers are using the large lever and wood block to help position the large planks. The deck was attached to the stringers with bolts and nailing cleats. (Courtesy ODOT.)

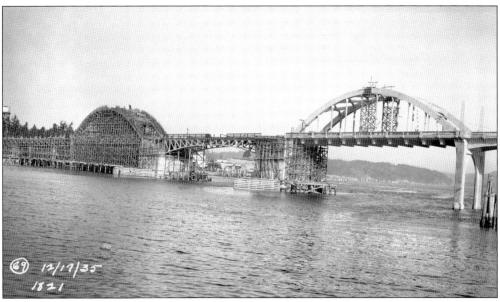

The falsework and forms for the north arch span and the north reinforced concrete deck girder approach spans are visible on December 17, 1935, and a portion of the handrail on the bascule spans is in place. Scaffolding is present on the main piers, but work on the pier houses has not been started. (Courtesy ODOT.)

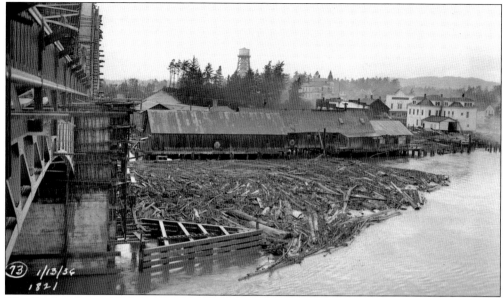

The Siuslaw River Bridge endured a high flood on January 13, 1936, during which a heavy accumulation of drift collected against the north arch falsework. The handrail on the bascule spans appears complete, and the north arch rib forms are visible. There is scaffolding on the main pier north of the navigation channel, but work on the pier house has not started. (Courtesy ODOT.)

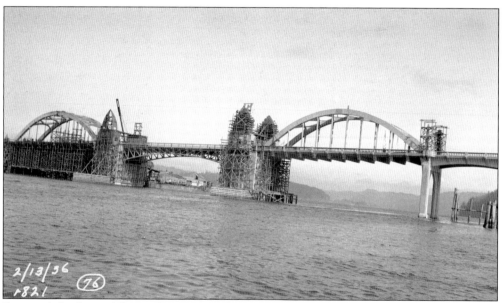

Formwork for three of the pier houses is in place on February 13, 1936, and the arch rib falsework has been removed from beneath the north arch ribs. A crane is visible over the main pier at the north side of the navigation channel. The pylons at the south end of the south arch span are surrounded by scaffolding. (Courtesy ODOT.)

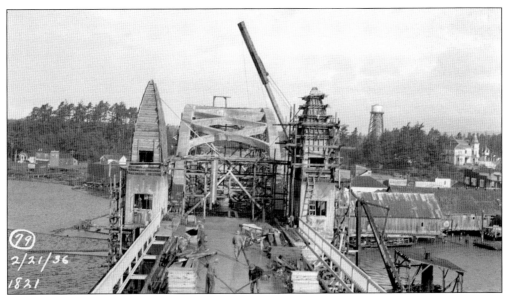

The north pier houses are approaching completion in this February 21, 1936, view. The forms have been removed from the north arch span ribs and bracing, and workers are installing sidewalk planks on the bascule span. The two men in the foreground are turning a large key that actuates the span locks, which lock the two bascule spans together when they are in the down position. (Courtesy ODOT.)

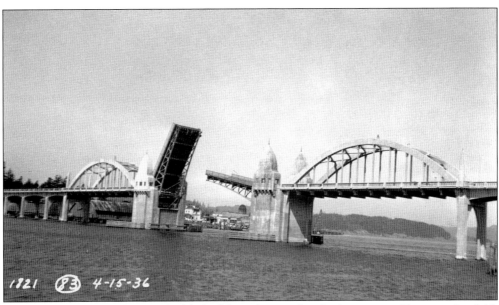

The Siuslaw River Bridge is a double-leaf, bascule-type drawbridge, pictured here on April 15, 1936, with one leaf open and one leaf partially open. Bascule-type bridges operate by rotating the leaf upward about a hinge anchored at the pier. McCullough used the large domes over the main piers to visually blend the bascule spans with the adjacent arch spans. (Courtesy ODOT.)

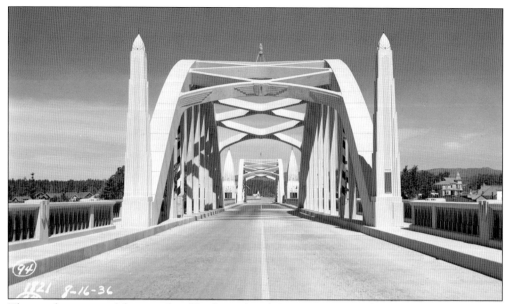

This roadway view of the completed bridge is dated August 16, 1936. The pylons at the entrance to the arches and the pier houses over the main piers at the navigation channel add much to the appearance of the bridge. The roadway is 27 feet wide, and the overall width of the bridge is 36 feet. (Courtesy ODOT.)

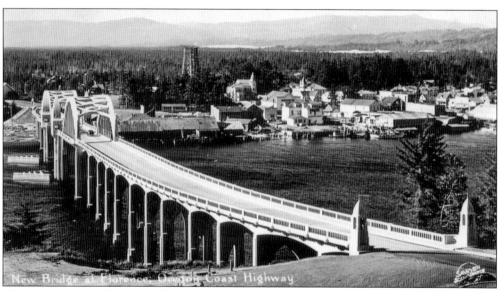

This photograph by Sawyers of Portland shows the newly completed Siuslaw River Bridge and the town of Florence from the southeast. Total cost of the 1,568-foot-long drawbridge was $502,127.10. Construction of this bridge employed an average of 140 men on 30-hour weeks with an average payroll of $3,000 per week. (Courtesy author collection.)

Five

UMPQUA RIVER BRIDGE (REEDSPORT)

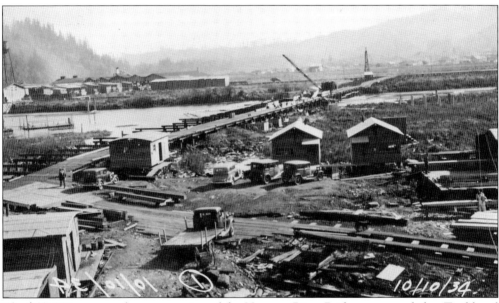

The $551,234 contract for construction of the Umpqua River Bridge was awarded to Teufel and Carlson of Seattle, Washington. This photograph of the south approach from the top of Teufel and Carlson's concrete plant, dated October 10, 1934, shows a work bridge, a crane working on a bridge pier, and a hoisting rig in the distance. C. B. McCullough and his designers selected a swinging-type drawbridge to fit this wide, shallow navigation channel. At the request of the U.S. Army Corps of Engineers, the design was changed from a 90-degree swing to an 80-degree swing, presumably to better match the navigation channel when the drawbridge is open. Because it would be easy for an automobile to drive off the bridge into the navigation channel when the bridge is open to marine traffic, the draw span is designed to be inoperable until the traffic gates are in place. (Courtesy ODOT.)

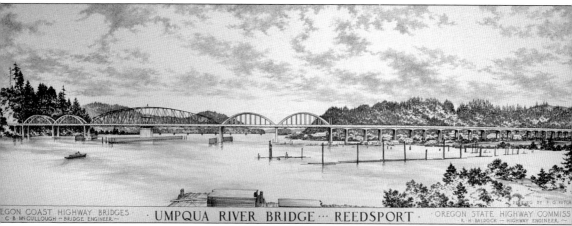

Oregon State Highway Department graphic artist Frank Hutchinson created this beautiful artistic rendition of the Umpqua River Bridge for the purpose of promoting the Oregon coast bridges. The shape of the steel Parker truss swing span harmonizes with the symmetric concrete tied arches to present a unique, pleasant appearance. Art deco and Moderne-style detailing adorned the arches, entrance pylons, piers, and reinforced concrete deck girder approaches. Construction of the bridge removed 4,068 cubic yards of soil and consumed 10,519 cubic yards of concrete, 39,739 lineal feet of piling, 1,175,191 pounds of reinforcing steel, and 1,335,921 pounds of structural steel. A large rock-cut of up to 140 feet deep through Bolon Island was required for the north approach roadway to match the elevation of the bridge. The 2,206-foot-long Umpqua River Bridge opened to traffic on July 2, 1936. (Courtesy Oregon State Archives.)

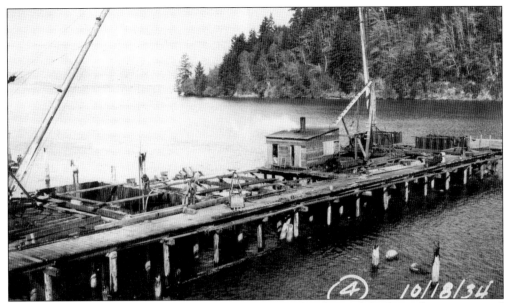

Two cofferdams at the Umpqua River Bridge are pictured with a work bridge and steam-powered pile driver on October 18, 1934. Sheet piling made of interlocking wooden planks or corrugated steel were driven all around each pier site to form a cofferdam, which was braced or shored so that the water could be pumped out, allowing workers to enter. (Courtesy ODOT.)

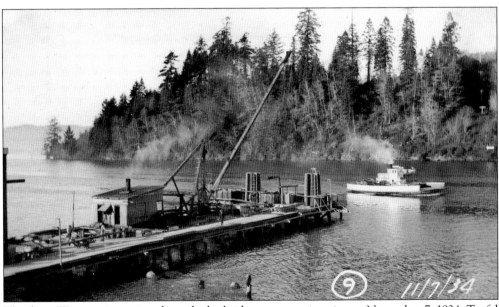

The ferry *Westport* is passing through the bridge construction site on November 7, 1934. Teufel and Carlson's hoisting rig, powered by a steam donkey, is working on a cofferdam for one of the bridge piers. This photograph also shows Bolon Island immediately to the north of the bridge site. (Courtesy ODOT.)

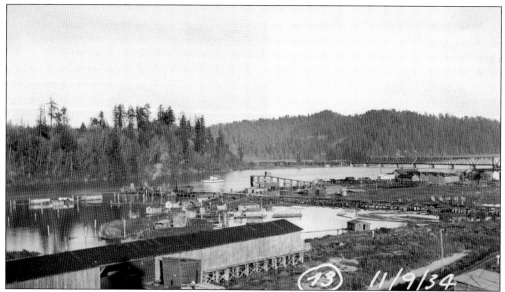

The bridge construction site is pictured from the south shore looking toward the northeast on November 9, 1934. Teufel and Carlson's concrete plant is near the center of this scene, which also shows many of the sheds and cabins used during construction of the bridge, the ferry *Westport* crossing nearby, and the Southern Pacific Railroad's bridge to the east. (Courtesy ODOT.)

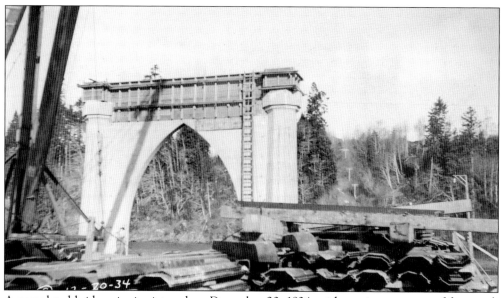

A completed bridge pier is pictured on December 20, 1934, with a minor amount of formwork still in place. The first fatal accident during construction of the Umpqua River Bridge happened December 17, 1934, when scaffolding failed only eight feet above the water, causing worker Albert Butler to fall, become trapped under a barge, and drown. (Courtesy ODOT.)

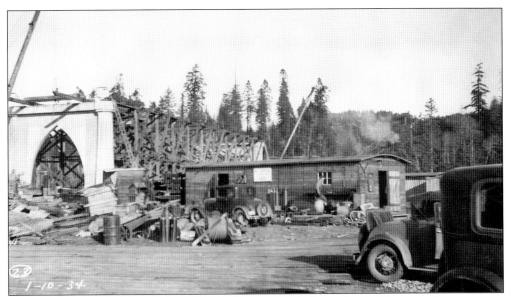

Teufel and Carlson completed these two bridge piers and this tied arch falsework, the temporary structure that supported the forms, by January 10, 1935. Tied arches are a bridge structure type with arch ribs above the roadway deck that serves as a tie to resist the horizontal thrust of the arch ribs. In the foreground, a parked Ford Model A has its rumble seat open. (Courtesy ODOT.)

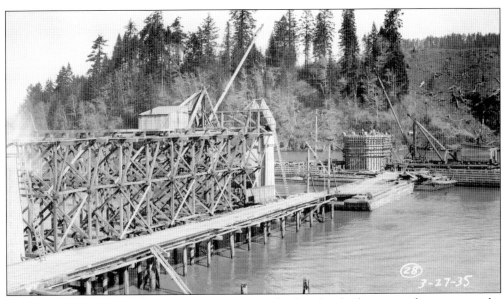

Teufel and Carlson completed the pier protection fenders for the large pier that supports the swing-type draw span by March 27, 1935. Hoisting rigs were mounted atop one of the fenders and the tied arch falsework. The work bridge was extended out to the draw span pier by building a pontoon bridge on several barges. (Courtesy ODOT.)

Two large girders are in place atop the main pier on May 10, 1935, waiting for the 430-foot Parker swing truss to be assembled in place, and much of the forms and falsework for the 154-foot tied arch south of the navigation channel are in place. The hoisting rig in the foreground is working on a pier north of the navigation channel. (Courtesy ODOT.)

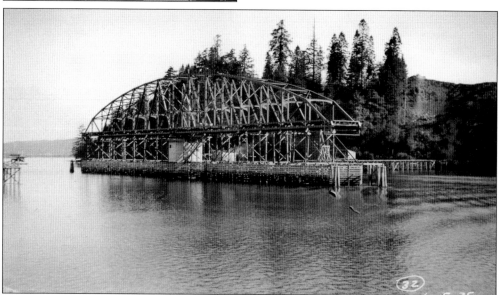

The 430-foot Parker swing truss is in place on the main pier in this photograph dated June 15, 1935. The falsework between the pier protection fender and the truss indicates that the truss was assembled above the fender with the navigation channel open to marine traffic. The truss was assembled in approximately five weeks. (Courtesy ODOT.)

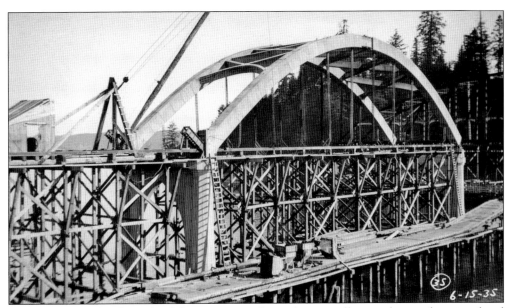

The 154-foot tied arch south of the navigation channel is partially complete in this view dated June 15, 1935, with the arch ribs and top bracing complete and reinforcing for the hangers in place. The concrete on the hangers was poured last, after the deck, to minimize built-in stresses that would cause cracking of the hanger concrete. (Courtesy ODOT.)

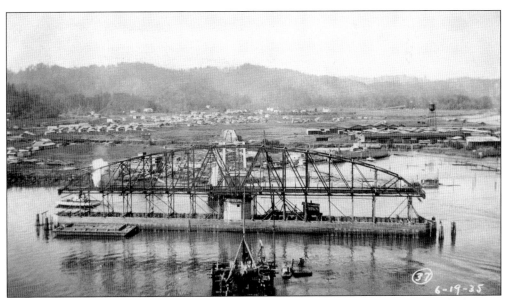

The 430-foot Parker swing truss is over the pier protection fender on June 19, 1935, with the ferry *Westport* passing to the south of the truss. A hoisting rig is working from a barge to the west of the pier on the opposite side of the fender. (Courtesy ODOT.)

Two men are examining the deck reinforcement for a portion of the reinforced concrete deck girder south approach in place above the deck forms in this June 19, 1935, photograph. The equipment and platforms visible in the background at left will be used to finish the deck concrete when it is poured. (Courtesy ODOT.)

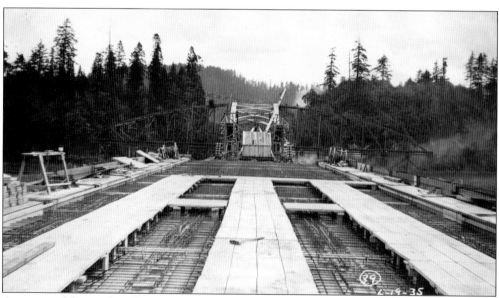

A portion of the reinforced concrete south approach spans is pictured here on June 19, 1935, ready for a deck concrete pour. Workers used the wooden platforms to place the concrete and removed them as the concrete was placed. In the background, one tied arch awaits deck concrete, and forms for the nearer tied arch are being built. (Courtesy ODOT.)

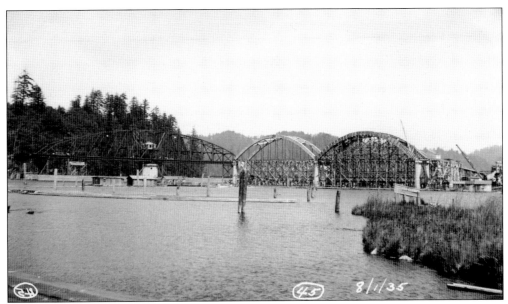

The forms and falsework for the second tied arch are nearly complete during July 1935, and the bridge operator's house is visible within the 430-foot swinging Parker truss. The month of July was grim with Jack Traylor fatally falling from a concrete arch on July 12 and George Moeck fatally falling into a cofferdam on July 15. (Courtesy ODOT.)

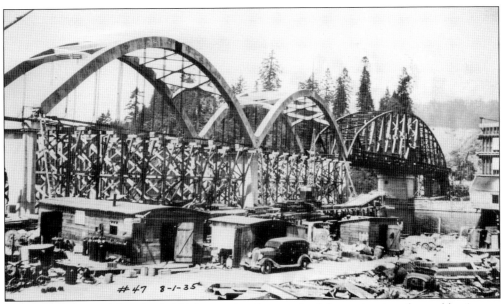

Forms were removed from both 154-foot tied arches south of the navigation channel by August 1, 1935. Falsework for deck concrete is in place as well as reinforcing for hangers still without concrete. Teufel and Carlson's concrete plant is visible in the foreground to the right. Here the swing span is now operable and is closed to marine traffic. (Courtesy ODOT.)

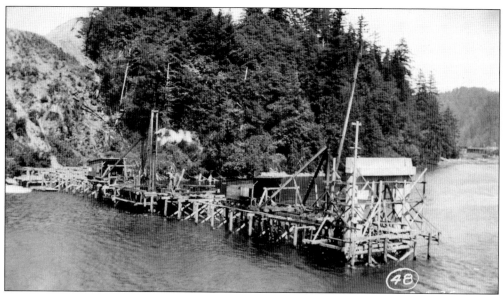

One pier for the tied arches north of the shipping channel is pictured here from the swing span on August 8, 1935. Two of Teufel and Carlson's hoisting rigs are working on tied arch falsework and piers, and the excavation of Bolon Island has not been started. (Courtesy ODOT.)

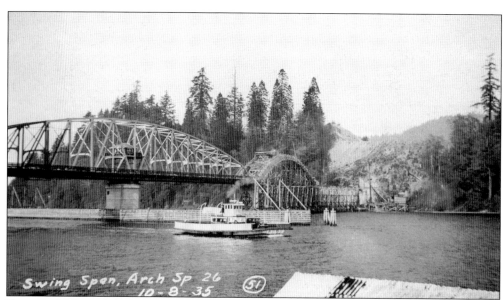

Forms and falsework for one 154-foot tied arch north of the navigation channel were visible, and falsework for the other 154-foot tied arch was partially complete by October 8, 1935. The ferry *Westport* is passing by the pier protection fender, which is also called a draw rest. The 430-foot swing span has been partially painted green. (Courtesy ODOT.)

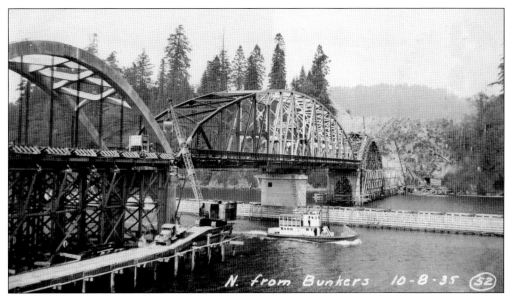

Bolon Island has been cleared in preparation for excavation in this view from the south on October 8, 1935. Also visible are a crane and a truck on the work bridge, a hoisting rig working on the north 154-foot tied arch, and the ferry *Westport* passing through the navigation channel. (Courtesy ODOT.)

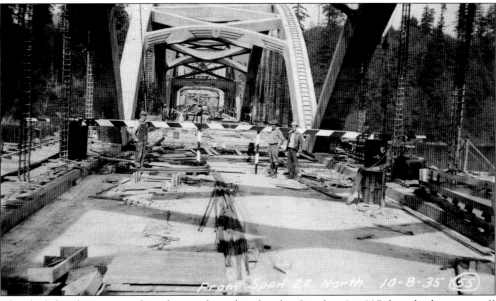

The deck has been poured in the south tied arches by October 8, 1935, but the hangers still were not poured. The traffic protection gates, operated from the two large boxes at each side of the deck, have been installed. The sidewalks and handrails have not been poured at this time. (Courtesy ODOT.)

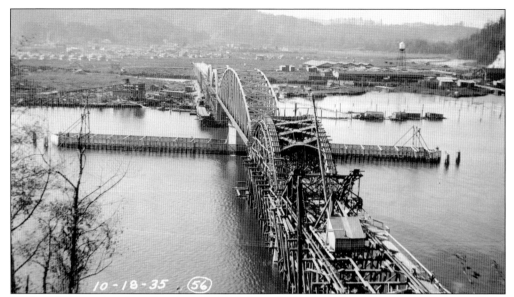

In this photograph taken October 18, 1935, from Bolon Island, a hoisting rig is mounted on falsework and working on the arch rib forms for the north tied arch. Most of the falsework has been removed from the pier protection fender except for a frame at each end that stabilizes the draw span while the bridge is open to marine traffic. (Courtesy ODOT.)

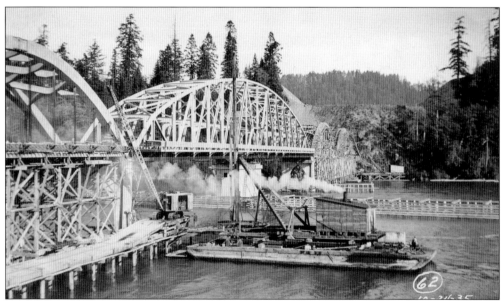

The 430-foot steel swing span was painted green by October 24, 1935, with arch rib forms and falsework in place for both tied arches north of the navigation channel. One of Teufel and Carlson's hoisting rigs is pictured here driving dolphins, pilings driven close together in a group and bound together to protect a bridge pier. (Courtesy ODOT.)

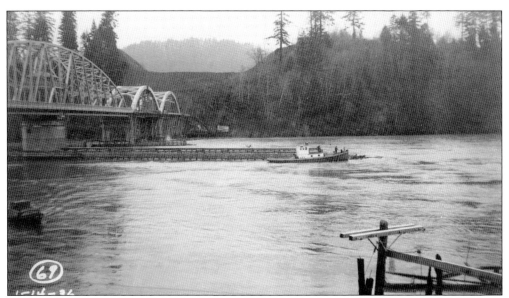

The Umpqua River Bridge endured a high flood on January 14, 1936. The tied arches north of the navigation channel have their arch ribs and top bracing completed, but their deck falsework is still in place. Excavation of Bolon Island will not begin until trucks can cross the bridge to remove the excavated rock and soil. (Courtesy ODOT.)

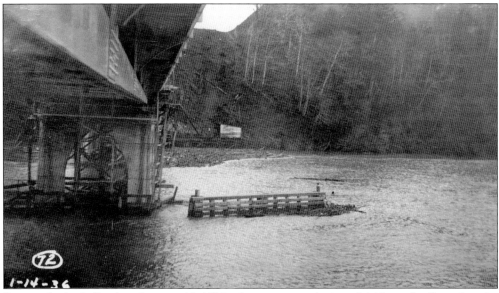

During the high flood on January 14, 1936, a heavy accumulation of driftwood collected at the north end of the Umpqua River Bridge. The accumulation of driftwood, combined with the flood, placed Teufel and Carlson's equipment, falsework, and work bridges at risk. It also put the partially completed bridge at some risk. (Courtesy ODOT.)

E. C. Hall's 45-ton, gasoline-powered Marion shovel was moved across the bridge on February 19, 1936, to work on the Bolon Island cut. The engine and other parts were removed and hauled separately to reduce the weight to 25 tons, and the shovel was towed by one of Hall's International tandem drive trucks. (Courtesy ODOT.)

One of E. C. Hall's three brand-new International tandem drive trucks, with eight cubic yard side dump boxes, is pictured here on February 29, 1936. Hauling approximately 100 cubic yards of fill material per hour for five months left the bridge dirty, and in late July 1936, Hall's crews cleaned it, removing several tons of material with brooms, scrub brushes, and a fire hose. (Courtesy ODOT.)

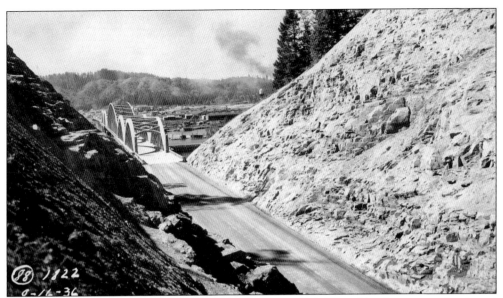

The large rock-cut through Bolon Island, also known as Tide Ways Island, was completed, and the bridge was cleaned up by August 16, 1936. This view shows the rock-cut and the freshly cleaned, completed Umpqua River Bridge, displaying the main 430-foot swing span flanked by four 154-foot tied arches. (Courtesy ODOT.)

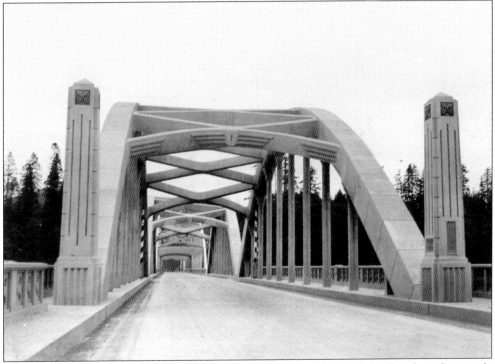

This roadway view of the completed bridge shows the tied arches and the fluted art deco–style entrance pylons. The pattern near the top of the pylons is similar to the unique pattern in the handrail. The Umpqua River Bridge has a 27-foot roadway width and a 37 foot overall width. (Courtesy ODOT.)

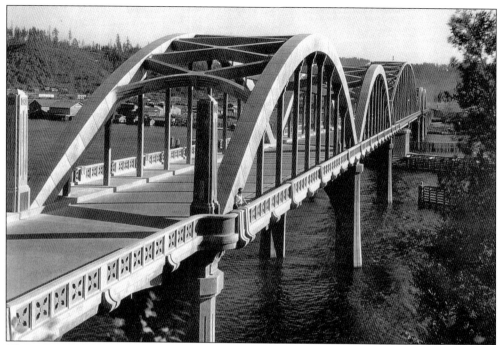

This view of the completed Umpqua River Bridge by photographer Cecil Ager shows a lone person enjoying the view of the river provided by the new bridge. This photograph provides a good illustration of the fluted art deco–style entry pylons, the concrete portal braces with scored decorative cartouches, the unique pattern in the handrail panels, and the curved elbow brackets that support the sidewalks. (Courtesy Carol Thilenius.)

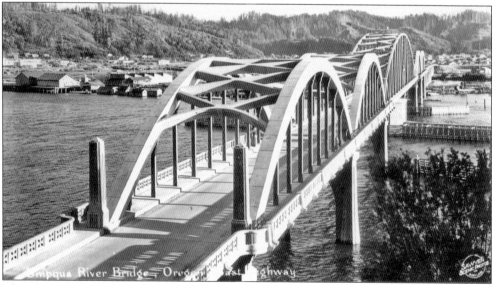

This photograph by Sawyers of Portland shows the newly completed Umpqua River Bridge and the town of Reedsport from the northwest, the art deco–style entry pylons, and the scored decorative cartouches on the portal braces. The total cost of the 2,206-foot-long drawbridge was $549,818.81, and construction of this bridge employed an average of 125 men on 30-hour weeks with an average payroll of $2,500 per week. (Courtesy author.)

Six

COOS BAY BRIDGE (NORTH BEND)

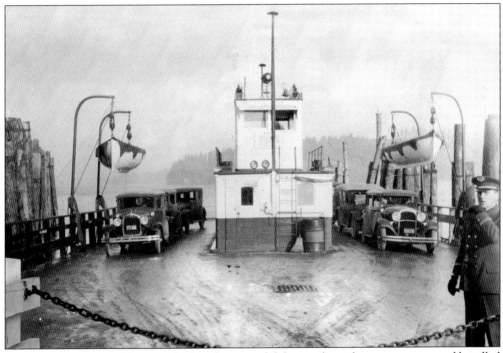

One of the North Bend ferries is docking between dolphins, pilings driven in a group and bundled together, at the North Bend landing. The ferryman is pictured, along with a 1928 or 1929 Ford Model A at left and two lifeboats. In the floor is a drain where water on the deck was collected and piped off the vessel. A chain blocked the ramp when the ferry was not loading or unloading. The $2,123,318 contract for construction of the Coos Bay Bridge was awarded to Northwest Roads Company and Virginia Bridge and Iron Company Northwest Roads was responsible for the piers and concrete work, while Virginia Bridge and Iron was responsible for erecting the steel cantilever truss over the main navigation channel. Fabrication of the components for the steel cantilever truss was subcontracted to American Bridge Company (Courtesy ODOT.)

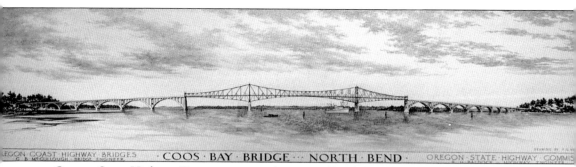

Oregon State Highway Department graphic artist Frank Hutchinson created this beautiful artistic rendition of the Coos Bay Bridge. The high position of the roadway in the cantilever truss and the truss's curved upper and lower chords allow the truss and the arches to present a harmonized appearance, resulting in an uncommonly graceful cantilever bridge. Art deco–style detailing adorned each part of the bridge. McCullough's staff engineers Raymond Archibald and Dexter Smith completed large portions of the design calculations and plans for the bridge. Construction of the bridge removed 24,331 cubic yards of soil and consumed 48,425 cubic yards of concrete, 209,895 lineal feet of piling, 5 million board feet of lumber for falsework, 4,337,571 pounds of reinforcing steel, and 7,505,803 pounds of structural steel. The bridge was dedicated during a celebration from June 5 to June 7, 1936, that included the coronation of Queen Cherry I, parades, foot races, banquets, a queen's ball, a marine parade, a luncheon, a Seattle orchestra, a log-bucking contest, a "jitney" dance, fireworks, a trap shoot, and an outdoor religious service. (Courtesy Oregon State Archives.)

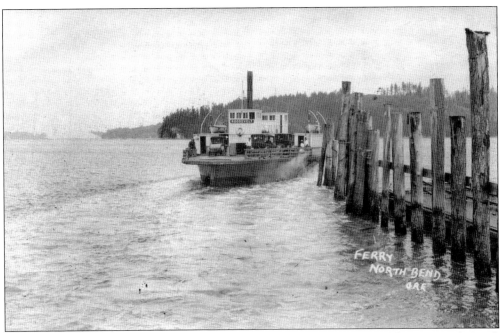

The Coos Bay ferry operation, which included the ferry *Roosevelt*, pictured here at North Bend, carried a record 345,922 cars in 1935. The coast bridges eliminated both the inconvenience and risks of ferries, such as an accident recounted in the June 1, 1936, *Coos Bay Times* in which an automobile crashed through the gates on a foggy night, causing several fatalities. (Courtesy ODOT.)

This interesting scale model of the Coos Bay Bridge, with a ship passing beneath, appears to be made of clear plastic or a similar material. The purpose of the model is unknown; it may have been simply to show the three-dimensional appearance of the bridge before the final design was accepted. (Courtesy Kenneth Archibald.)

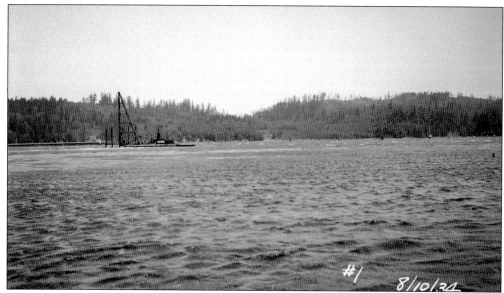

The first step in constructing the Coos Bay Bridge was to build a work bridge for the traveling derricks that delivered and hoisted materials to the bridge. Pictured here is the driving of the first piling for the work bridge on August 10, 1934. The first injury on Coos Bay Bridge occurred when a powder "monkey" was hit by a piece of flying stump on August 4, 1934. (Courtesy ODOT.)

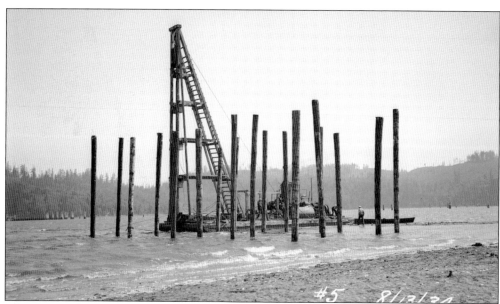

This close-up view, dated August 13, 1934, shows the pile-driving operation near the south shore with a Northwest Roads pile driver mounted on a barge. The pile driver is powered by a steam donkey engine that raises the hammer for each blow. The boat used for access to the pile driver is visible at right of the barge. (Courtesy ODOT.)

Seventy-foot piling to be used in pier protection fenders was being treated with preservatives on September 19, 1934. The tips of the poles were fitted with apparatus, visible at right, which allowed the arsenic copper and zinc sulfate preservatives to be forced into the wood. (Courtesy ODOT.)

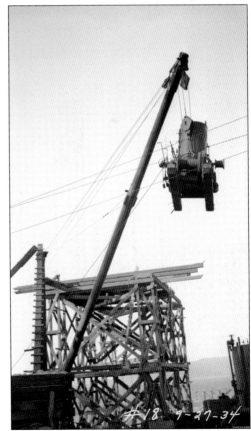

A steam donkey engine is being raised by Northwest Roads' gantry on September 27, 1934. The donkey engine is being placed on Northwest Roads' traveler, visible in the background, which carries supplies and equipment along the work bridge. To the lower right another donkey engine is partially visible. (Courtesy ODOT.)

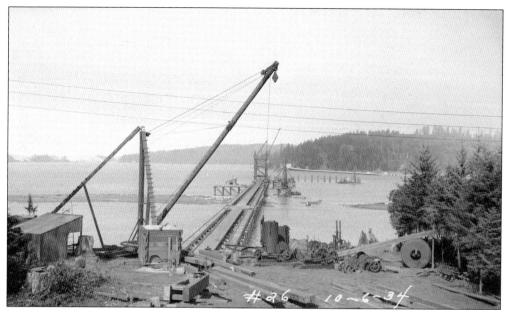

The work bridge is pictured here on October 6, 1934, with the traveler at work and a platform supporting a small shed at the edge of the mud flats. The dolphins, pilings driven close together in a group and bound together that form the pier protection fender, are visible to the east of the work bridge. (Courtesy ODOT.)

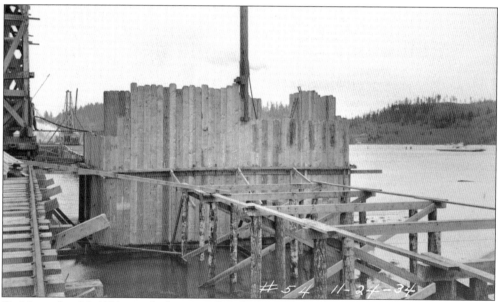

On November 24, 1934, interlocking wooden sheet piling is being driven to form a cofferdam at a pier. The cofferdam was then braced or shored so that the water could be pumped out, allowing workers to enter. A layer of seal concrete at the bottom helped keep water out during later work. (Courtesy ODOT.)

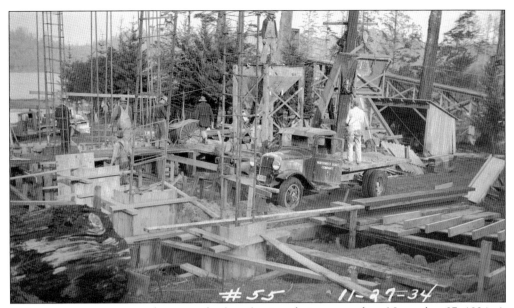

This concrete pour scene shows south plaza footings being poured on November 27, 1934. A hopper of concrete is being hoisted from the bed of a Northwest Roads 1934 Ford truck, and concrete workers are using carts to deliver the concrete to each footing. Column-reinforcing bars are protruding from each footing. (Courtesy ODOT.)

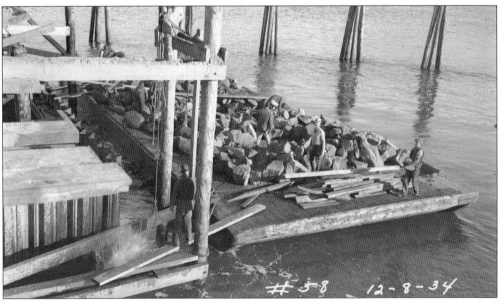

Workers on a barge are placing riprap, heavy rock that protects the pier from the loss of streambed material to flowing water, around the main pier south of the navigation channel in this December 8, 1934, photograph. The steel sheet pilings that form the cofferdam for this pier are visible at left and the pier protection fender is in the background. (Courtesy ODOT.)

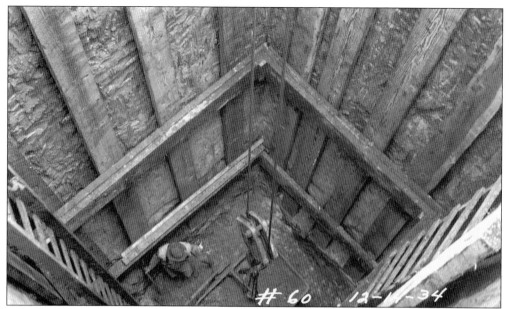

The excavation of a footing to support a portion of the south approach is pictured here on December 14, 1934. The timbers and planks are the shoring that prevents the earth from caving in on the excavation. The excavating bucket is visible in the mud at the bottom of the excavation. (Courtesy ODOT.)

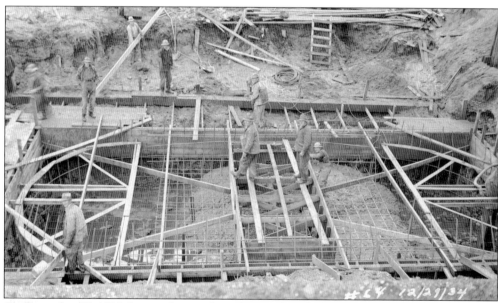

On December 29, 1934, formwork is ready at this south arch span pier along with curved guides to hold vertical reinforcing bars in position. Because the earth around this pier is out of the water, a cofferdam is not needed, even though the top of the forms is three feet below sea level. (Courtesy ODOT.)

With six inches of snow on the ground on January 19, 1935, much of the bridge construction work is on hold, as reflected in the lack of footprints in the snow near the outhouse for the field engineer's office. Some wag has added a "For Rent" sign to the forlorn outhouse. (Courtesy ODOT.)

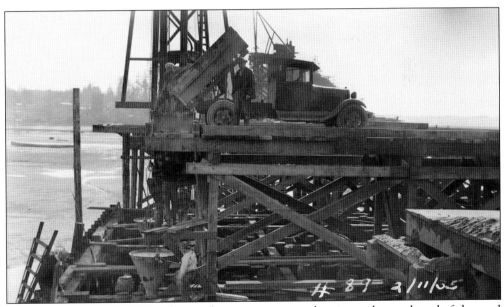

A truck is delivering concrete for a seal concrete pour in the pier at the south end of the steel cantilever truss on February 11, 1935. A heavy-duty platform built on top of the shoring allows the truck to dump the concrete into a system of chutes that carry the concrete to the bottom of the cofferdam. (Courtesy ODOT.)

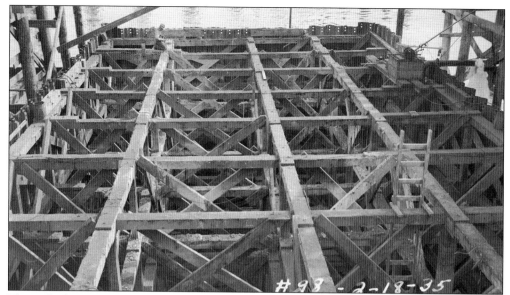

The cofferdam for the main pier south of the navigation channel is pictured with its timber shoring on February 18, 1935. The shoring kept the cofferdam from collapsing under the hydrostatic pressure of the water around it. Seven days later, on February 25, 1935, the state project inspector's notes state, "Fell and broke my ribs." (Courtesy ODOT.)

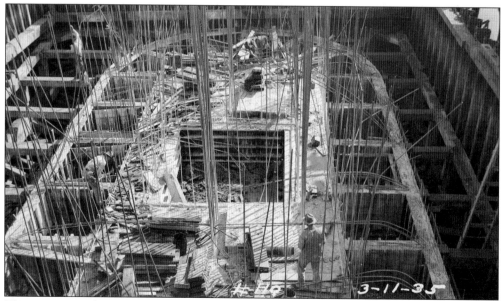

The concrete in the main pier south of the navigation channel was poured up to seven and a half feet above sea level by March 11, 1935. The curved ends of the pier, bracing of the forms against the cofferdam walls, and the cellular, or hollow, construction of the pier are clearly pictured. (Courtesy ODOT.)

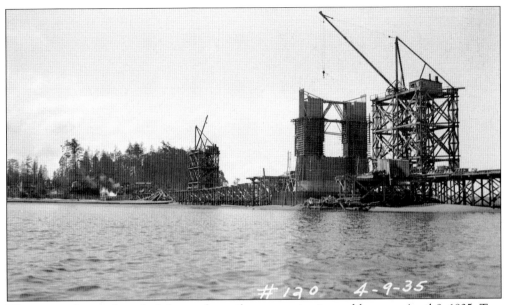

The pier at the south end of the steel cantilever truss is pictured here on April 9, 1935. Two of Northwest Roads' traveler derricks are visible, with one working on the pier. The sheet pilings are visible just above water level along with some of the formwork for the upper pier. (Courtesy ODOT.)

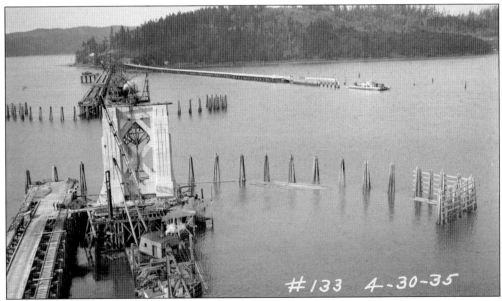

This view looking north from the pier at the south end of the steel cantilever truss is dated April 30, 1935. A crane is working on the main pier south of the navigation channel. The North Bend ferry is visible near its north landing, which is a long bridge in its own right. (Courtesy ODOT.)

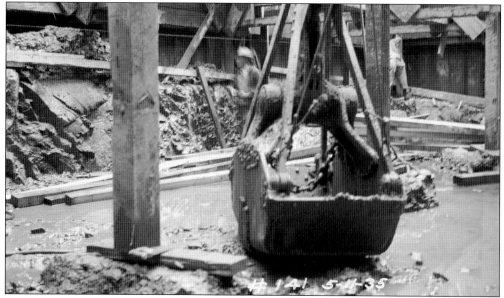

Excavation of the pier at the north end of the bridge is pictured on May 11, 1935. The excavator bucket is being operated by one of the Northwest Roads hoisting rigs and some sheet piling and timber shoring is visible. The post in the foreground supports the main shoring timbers overhead. (Courtesy ODOT.)

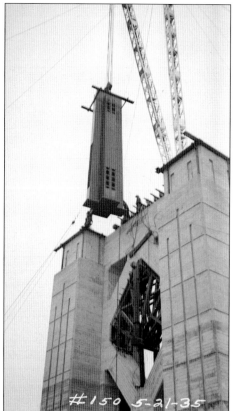

The first piece of structural steel is being set in place atop the main pier south of the navigation channel in this May 21, 1935, view. This marks the beginning of Virginia Bridge and Iron Company's work on the bridge. Some of the falsework, the temporary structure that supports the forms, between the braces in the pier is still in place. (Courtesy ODOT.)

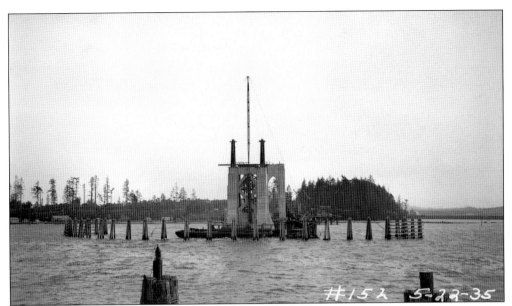

The second piece of structural steel is in place atop the main pier south of the navigation channel on May 22, 1935. In the background, the pier at the south end of the steel cantilever truss appears complete. This day's state project inspector's notes state, "Too windy to work all morning." (Courtesy ODOT.)

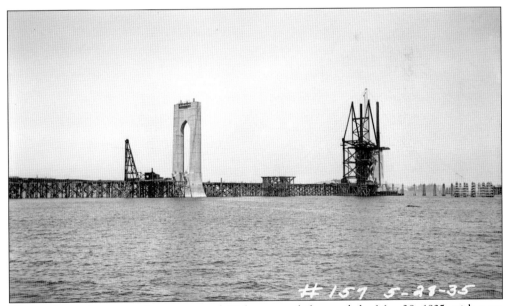

The steel cantilever truss has progressed 62 feet toward the south by May 28, 1935, with sway bracing and several side and bottom members of the truss in place. At this time, a system of temporary supports is holding up the truss and the highest members are above roadway level. (Courtesy ODOT.)

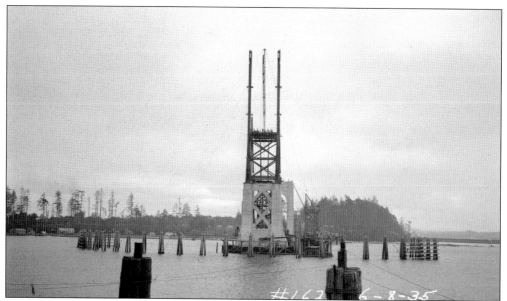

The columns reach full height above the main pier south of the navigation channel in this photograph taken June 8, 1935. Many stabilizing guy lines are attached to the two booms of the derrick that is being used to lift steel members into place. Some of the structural steel floor framing is in place. (Courtesy ODOT.)

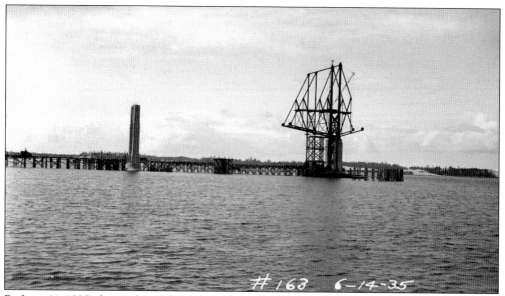

By June 14, 1935, the steel cantilever truss is beginning to take shape over the main pier south of the navigation channel. Several top members of the truss and three sets of sway bracing are in place. Floor framing appears to be in place for approximately 124 feet of roadway deck. (Courtesy ODOT.)

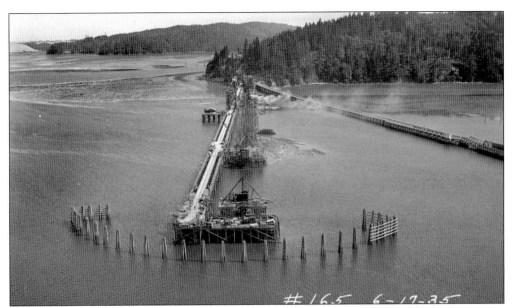

The highest point on the steel cantilever truss provided this view of the north half of Coos Bay Bridge construction on June 17, 1935. Two of Northwest Roads' traveler derricks are operating on the north work bridge, the north ferry landing is visible, and the cantilever truss piers behind the north pier protection fender are under construction. (Courtesy ODOT.)

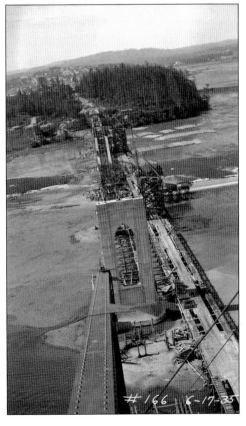

A climb to the highest point on the steel cantilever truss, looking toward the south, provided this scene on June 17, 1935. One of the upper members of the steel cantilever truss is visible, pointing toward the pier to the south. Two traveling derricks are operating on the work bridge, and some of the timber falsework to support the forms for the reinforced concrete deck arch spans is visible. (Courtesy ODOT.)

The highest point on the steel cantilever truss also provided this view looking downward on June 17, 1935. Some of the rigging used by Virginia Bridge and Iron is on the planks placed over a portion of the floor framing. The two latticed booms are part the derrick used to place steel truss members. (Courtesy ODOT.)

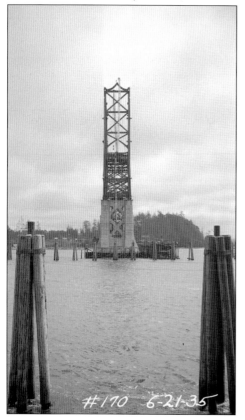

The graceful curved members at the top of the tower are in place and construction of the steel cantilever truss is progressing toward the north on June 21, 1935. Virginia Bridge and Iron's two derrick booms are visible among the truss members. The stabilizing guy lines attached to the derrick booms are faintly visible. (Courtesy ODOT.)

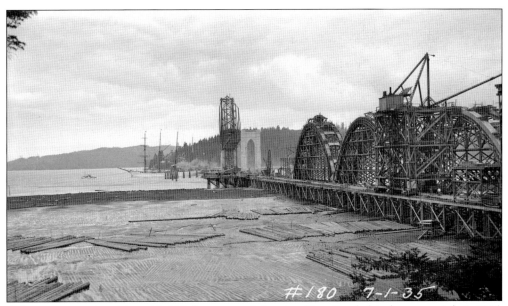

A Japanese training ship, with 200-foot masts, is leaving Coos Bay behind a tug on July 1, 1935. The completed bridge provides 145 feet of vertical clearance above mean sea level. Elsewhere on the project on this date, a worker named Harris fell in one of the piers for the north reinforced concrete deck arch spans, fracturing his skull. (Courtesy ODOT.)

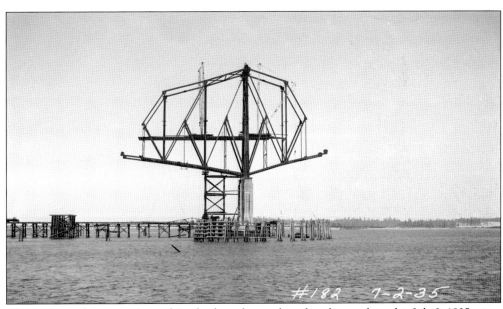

The steel cantilever truss is reaching both to the south and to the north in this July 2, 1935, view. Virginia Bridge and Iron's derrick with two booms is visible just north of the main columns. A second derrick, also with two booms, has been added approximately 70 feet south of the main columns. (Courtesy ODOT.)

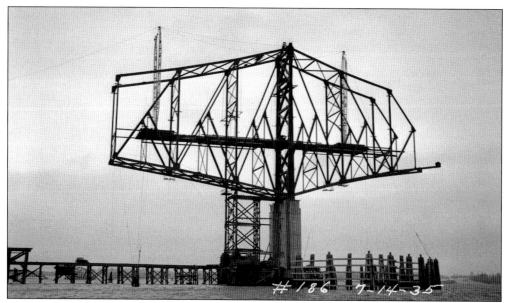

The steel cantilever truss has extended considerably to the south and to the north by July 14, 1935. One of the derricks has been moved to approximately 70 feet north of the main columns, and the second derrick has been moved to approximately 145 feet south of the main columns. Only the original temporary supports are stabilizing the truss. (Courtesy ODOT.)

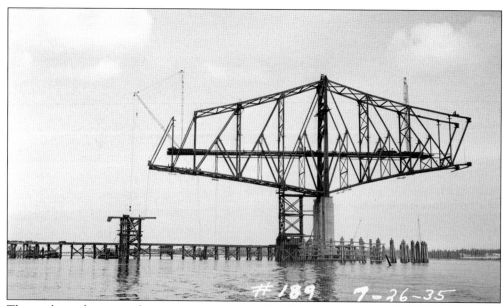

The steel cantilever truss has grown again on July 26, 1935, with one derrick approximately 130 feet north of the main columns and the other approximately 210 feet south of the main columns. The truss appears neatly balanced on the main pier and the original temporary support. The derrick is picking up a large piece of structural steel from the traveler. (Courtesy ODOT.)

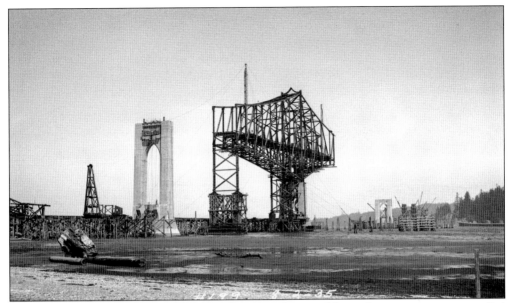

The steel cantilever truss has extended to the point that an additional temporary support, called a false bent, is needed to stabilize the structure by August 2, 1935. This view shows the newly constructed false bent in place, the nearly completed main pier north of the navigation channel, and formwork on the pier at the north end of the steel cantilever truss. (Courtesy ODOT.)

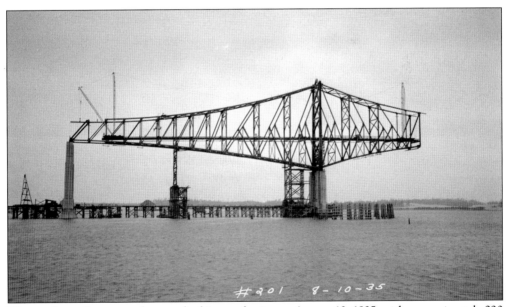

The steel cantilever truss has reached its south pier on August 10, 1935, with approximately 220 feet north of the main pier and approximately 465 feet south of the main pier. The south derrick is supporting a top truss member while it is being installed. Approximately 120 feet of handrail is visible north of the main pier. (Courtesy ODOT.)

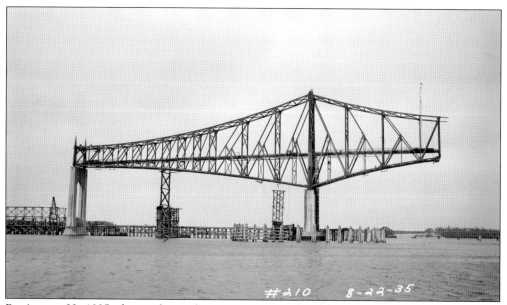

By August 22, 1935, the steel cantilever truss is completed between the main pier south of the navigation channel and its south end. The temporary support close to the main pier is being dismantled, and approximately 186 feet of handrail has been added near the south end. (Courtesy ODOT.)

The columns above the main pier north of the navigation channel have reached their full height by September 17, 1935. These workers, one using a sling to keep from sliding down the brace, appear to be preparing a structural joint for riveting. They used the block and tackle with the bucket to bring up supplies and tools. The Southern Pacific Railroad Bridge is visible to the west. (Courtesy ODOT.)

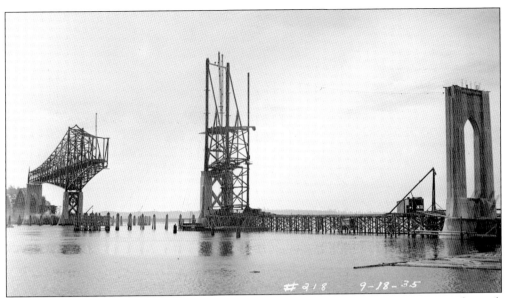

The temporary support is in place to hold up the truss members north of the navigation channel, and a derrick with two booms is in place at the main pier in this photograph taken on September 18, 1935. Some of the falsework for the bracing in the main pier south of the navigation channel has not been removed yet. (Courtesy ODOT.)

Using an oxy-acetylene torch, a diver is cutting off the sheet piling around the main pier south of the navigation channel on September 26, 1935. A worker at the surface is walking on a plank to hook the line from the crane to some of the last sheet piling being removed. (Courtesy ODOT.)

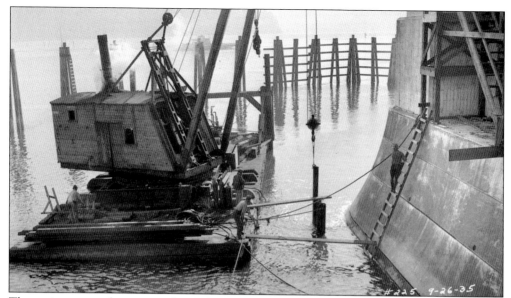

The equipment used to remove sheet piling around the main pier south of the navigation channel is seen here on September 26, 1935. Northwest Roads' barge-mounted, steam-powered crane is being used to pull up the sections of steel sheet piling after they have been cut off. A plank provides access to the barge from a ladder on the pier. (Courtesy ODOT.)

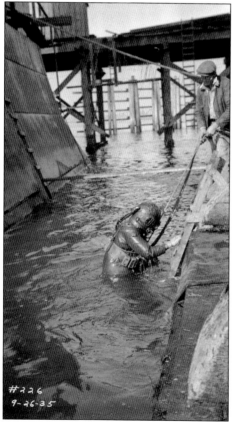

A diver is coming up after cutting off sheet piling around the main pier south of the navigation channel on September 26, 1935. In the foreground, on the deck of the barge, are the skids that support the crane. In the background are the Northwest Roads work bridge and the pier protection fender. (Courtesy ODOT.)

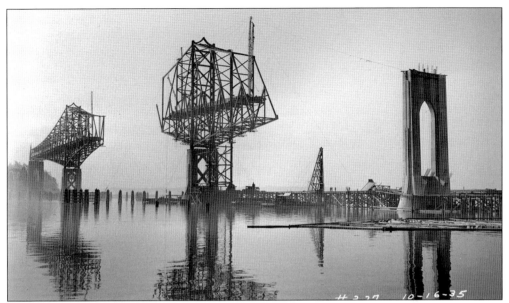

The north portion of the steel cantilever truss extends approximately 186 feet to the north and 124 feet to the south on October 16, 1935. Approximately 250 feet of handrail is visible, and the pier at the north end of the truss appears complete. The anchor rods protruding from the north pier will anchor the adjacent reinforced concrete deck arch span. (Courtesy ODOT.)

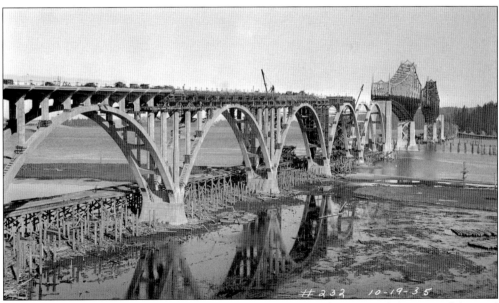

Looking north from Northwest Roads' concrete plant on October 19, 1935, portions of the steel cantilever truss have been painted green, and the south reinforced concrete deck arch spans are in varying states of completion. At the south end, the arch is complete except for handrails and removal of some forms, while at the north end the arch lacks columns, a floor system, and handrails. (Courtesy ODOT.)

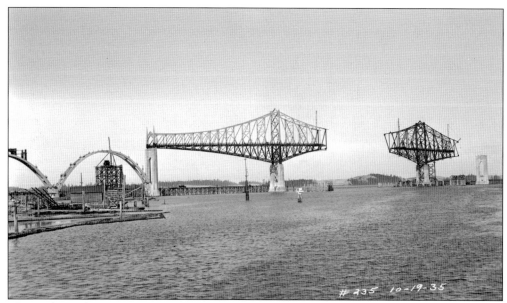

The steel cantilever truss is partially completed and partly painted green in this view of Coos Bay Bridge on October 19, 1935. Virginia Bridge and Iron has left one derrick in place on the south truss portion, where construction of the main span will continue when the north truss portion is finished. (Courtesy ODOT.)

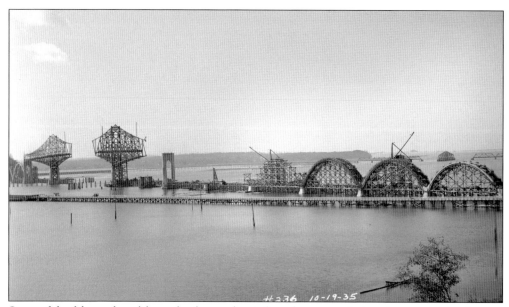

Some of the falsework and forms for the north reinforced concrete deck arch spans are in place on October 19, 1935, and construction of the steel cantilever truss continues with only the original temporary support in place. In the foreground is the north ferry landing, and in the background is the Southern Pacific Railroad Bridge. (Courtesy ODOT.)

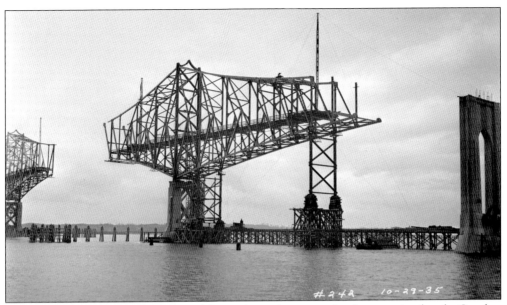

The false bent for the north portion of the steel cantilever truss has been put in place by October 29, 1935. On November 1, 1935, carpenter Raymond Brown fell from a work trestle and broke his neck, passing away on November 3 as a result of his injuries. The work trestle had a guardrail about a foot high. (Courtesy ODOT.)

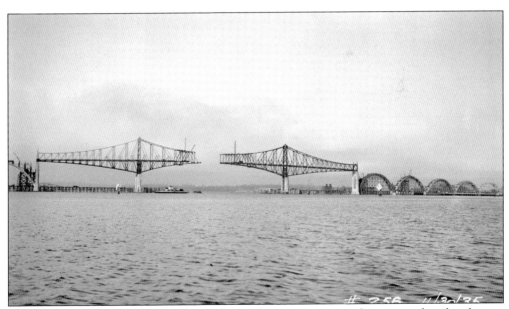

The north and south halves of the steel cantilever truss are reaching toward each other on November 30, 1935, and the falsework and forms for the last arch spans are in place. The North Bend ferry *Roosevelt* is passing by the east side of the bridge near the navigation channel. The Coos Bay Dredging Company, the only bidder, purchased the *Roosevelt* at auction on May 22, 1936, for $338.50. (Courtesy ODOT.)

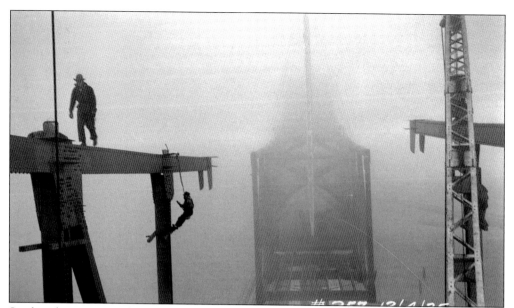

Steel workers are at work on a foggy day in this photograph dated December 4, 1935. One worker is suspended from the top of the truss, and another is walking along the top member, the upper chord, of the truss. The north portion of the truss is visible through the haze. (Courtesy ODOT.)

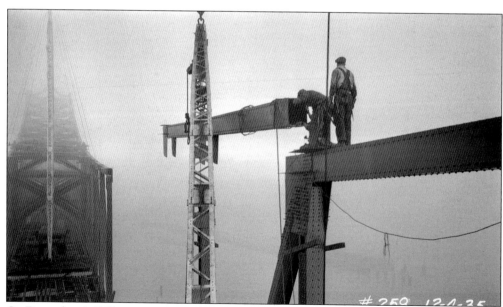

On December 4, 1935, a top truss member, an upper chord, is being put in place by Virginia Bridge and Iron's derrick. The north and south parts of the steel cantilever truss are rapidly approaching each other. The north ferry landing is faintly visible through the fog. (Courtesy ODOT.)

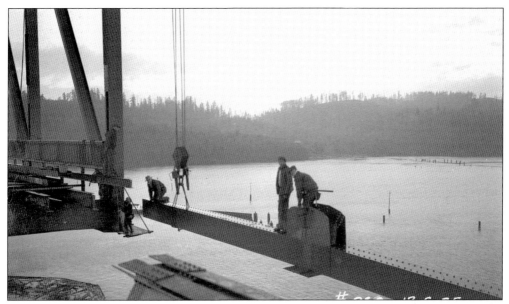

One of the last bottom truss members, a lower chord, is being put in place to connect the north and south portions of the steel cantilever truss in this photograph dated December 6, 1935. One of the three steel workers on the chord appears to be helping guide it into position. (Courtesy ODOT.)

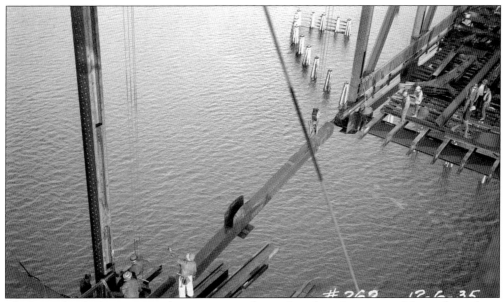

The lower chord is being put in place to connect the north and south portions of the steel cantilever truss on December 6, 1935. One worker is signaling the derrick operators to guide the chord into final position. The gap being closed at this time is 62 feet. (Courtesy ODOT.)

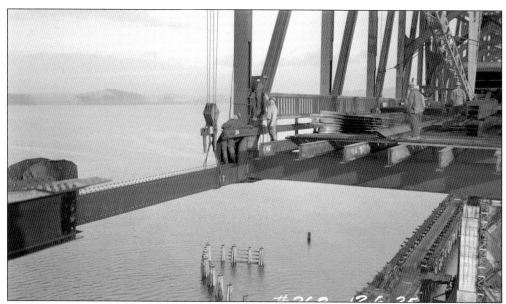

The lower chord appears to be in its final position on December 6, 1935. A worker is signaling the derrick operators while others appear to be waiting to rivet the chord into place. Other truss members awaiting placement are visible on the planks laid on the floor framing. (Courtesy ODOT.)

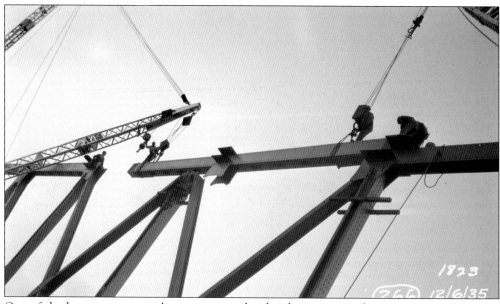

One of the last top truss members, an upper chord, is being put in place to connect the north and south portions of the steel cantilever truss on December 6, 1935. Several steel workers are on the chord. Truss members, including a post and braces, have been placed since the lower chord was put in place earlier in the day. (Courtesy ODOT.)

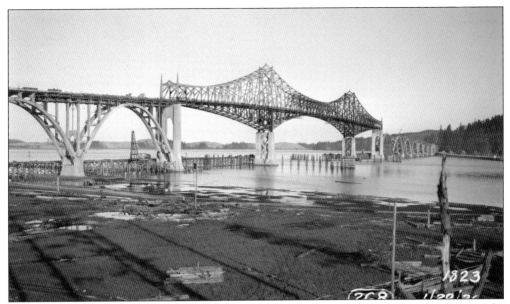

The steel cantilever truss is complete and partially painted green by January 29, 1936, about eight months after Virginia Bridge and Iron began work. The south reinforced concrete deck arches appear complete up to the deck, which still has some forms in place, and the north reinforced concrete deck arches appear to be progressing but still need columns and a deck. (Courtesy ODOT.)

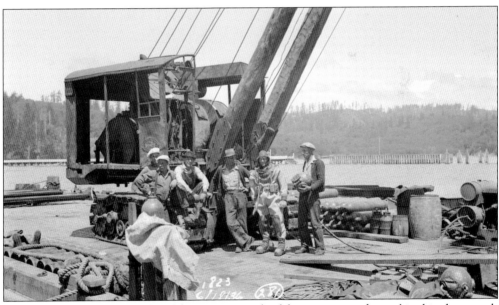

A diver and crew are pictured at the main pier north of the navigation channel in this photograph taken on June 18, 1936. On May 7, 1936, a scaffold plank slipped and Alvy Smith, who was removing forms from the north arch next to the cantilever truss, was thrown and fatally fell about 135 feet. The other man on the plank, Les Burns, was thrown toward the bridge and escaped injury. (Courtesy ODOT.)

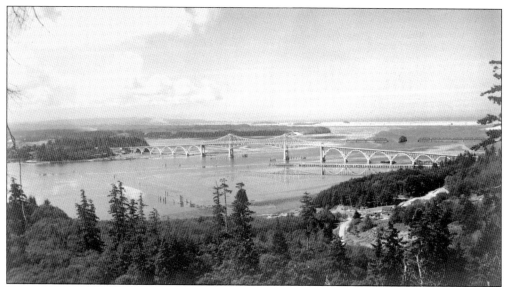

This view shows the completed bridge from the east, and a portion of Coos Bay, with the Southern Pacific Railroad Bridge, Cape Arago, and the Pacific Ocean in the background. Not much of the work bridges are left but the north ferry landing, now obsolete, is still visible in the right foreground. (Courtesy ODOT.)

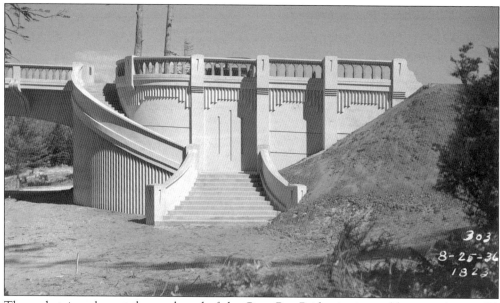

The pedestrian plaza at the south end of the Coos Bay Bridge is pictured here on August 25, 1936, with "streamlined" stairways leading up to the sidewalks on the bridge. This view shows the south plaza with its art deco and Moderne-style stairways, handrails, walls, and vertical and horizontal patterns. Also visible are stylized Gothic-style arch railing panels that match those on the bridge. (Courtesy ODOT.)

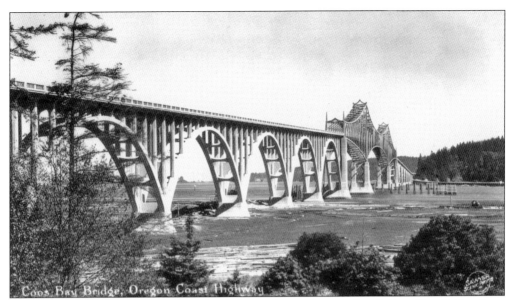

This photograph by Sawyers of Portland shows the newly completed Coos Bay Bridge from the southeast. The total cost of the 5,305-foot—just over one mile—bridge was $2,090,865.14. Construction of this bridge employed an average of 250 men on 30-hour weeks with an average payroll of $7,000 per week and a peak employment of 650 men. Laborers earned 50¢ per hour, and semiskilled workers earned 75¢ per hour. (Courtesy author.)

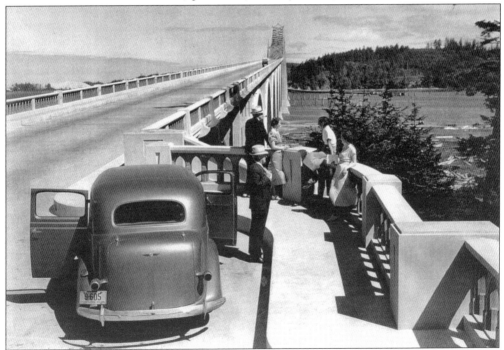

This view of the Coos Bay Bridge by photographer Cecil Ager shows a group of motorists relaxing and enjoying the view of the newly completed bridge. They have parked their 1936 Dodge sedan at the south pedestrian plaza, which provided a convenient spot for viewing the bridge and Coos Bay. (Courtesy Carol Thilenius.)

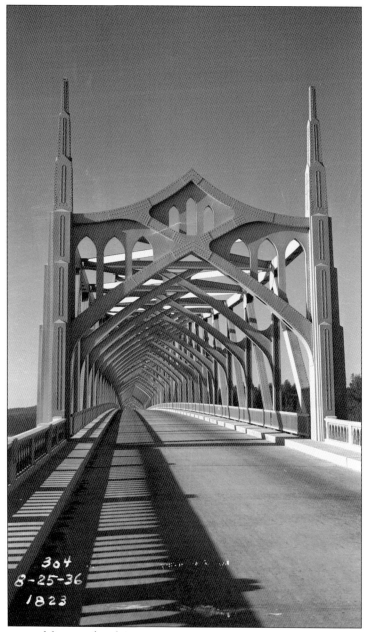

This roadway view of the completed Coos Bay Bridge is dated August 25, 1936. The portal members and all of the sway bracing through the cantilever are shaped like a Gothic arch, as are the smaller openings between the portal members. The entrance pylons have art deco–style detailing. The roadway is 27 feet wide, and the overall width of the bridge is 37 feet. Even a well-built bridge like this one requires regular maintenance. According to the June 1, 1936, *Coos Bay Times*, the engineers described maintenance as "regular inspection of all surfaces on the bridge, painting the steel when needed, replacing any railings knocked out by cars, and perhaps adding a one-inch coat of black top to the deck when it becomes rough in 25 to 50 years." The engineers also noted that the drains need to be kept open, the aerial and marine navigation lights need to be kept on, and that additional coats of paint would be needed every 5 to 10 years. (Courtesy ODOT.)

BIBLIOGRAPHY

Branson, Olive. *Hardships of Travel in Early Days.* Pioneer History of North Lincoln County, Oregon, Volume I, North Lincoln Pioneer and Historical Association. McMinnville, OR: Telephone Register Publishing Company, November 1951.

Gemeny, Albin L., and Conde B. McCullough. *Application of Freyssinet Method of Concrete Arch Construction to the Rogue River Bridge in Oregon.* Salem, OR: Oregon State Highway Commission, April 1933.

Hadlow, Robert W. *Elegant Arches, Soaring Spans: C. B. McCullough, Oregon's Master Bridge Builder.* Corvallis, OR: Oregon State University Press, 2001.

Hool, George A., and W. S. Kinne. *Reinforced Concrete and Masonry Structures.* (Section 8, "Arches" by C. B. McCullough.) New York: McGraw-Hill Book Company, Inc., 1924.

http://bluebook.state.or.us/state/executive/Transportation_Dept/transportation_dept_history. htm. Oregon Department of Transportation Agency History. Oregon Bluebook Online. February 22, 2005.

Library of Congress, Historic American Engineering Record, National Park Service, U.S. Department of the Interior, *Conde B. McCullough and Oregon Coast Bridge Records.*

Salem, Oregon. Department of Transportation. History Center. Ferry Photograph File.

Salem, Oregon. Department of Transportation. Technical Services. Bridge Section. Bridge Maintenance Files.

———. Department of Transportation. Technical Services. Bridge Section. Historic Bridges Photograph Collection.

———. Department of Transportation. Technical Services. Bridge Section. Microfiche Contract Files.

Salem, Oregon, State Archives. Hutchinson and Spooner Drawings Collection.

Stembridge, James E. Jr. *Pathfinder, The First Automobile Trip From Newport to Siletz Bay, Oregon, July 1912.* Lincoln County Historical Society, Newport, Oregon. Dallas, OR: Itemizer-Observer, 1975.

DISCOVER THOUSANDS OF LOCAL HISTORY BOOKS FEATURING MILLIONS OF VINTAGE IMAGES

Arcadia Publishing, the leading local history publisher in the United States, is committed to making history accessible and meaningful through publishing books that celebrate and preserve the heritage of America's people and places.

Find more books like this at
www.arcadiapublishing.com

Search for your hometown history, your old stomping grounds, and even your favorite sports team.